POSTCARD HISTORY SERIES

New York City Skyscrapers

POSTCARD HISTORY SERIES

New York City Skyscrapers

Richard Panchyk

ARCADIA
PUBLISHING

Published by Arcadia Publishing
Charleston, South Carolina

Printed in the United States of America

Library of Congress Control Number: 2009940062

For all general information contact Arcadia Publishing at:
Telephone 843-853-2070
Fax 843-853-0044
E-mail sales@arcadiapublishing.com
For customer service and orders:
Toll-Free 1-888-313-2665

Visit us on the Internet at www.arcadiapublishing.com

For Mimi

CONTENTS

Acknowledgments

Thanks go to the dedicated team at Arcadia, especially my excellent editors, Erin Vosgien and Tiffany Frary. Thanks also to my family and friends for their support in helping me reach new heights. All the postcard images in this book are from the author's collection. Photographs from the Library of Congress are indicated.

INTRODUCTION

This book tells the remarkable and fascinating story of New York's tallest buildings through picture postcards, from the earliest days when the spires of Trinity Church, St. Patrick's Cathedral, and others were the tallest structures in sight, all the way through the 1980s when the Twin Towers ruled the skyline.

It was a unique combination of factors that came into play at the end of the 19th century to allow the construction of buildings taller than a few stories. The use of structural steel to frame buildings was one factor. It allowed for much greater flexibility than stone or wood. Another factor was more efficient excavation techniques allowing the deep trenches necessary for tall building foundations. The invention of the elevator in the 1850s was a major factor. Office workers or apartment dwellers could not be expected to climb more than five or six flights of stairs. The elevator meant the people could quickly and effortlessly be shuttled to any floor, no matter how high above the ground. And finally, the availability of huge amounts of capital from large corporations and wealthy investors was also important.

Since the construction of the first true skyscrapers in the late 1880s, New York's tall buildings have captured the imagination of residents and visitors alike. As technology improved and ambition increased, New York remained at the forefront of skyscraper construction with the construction of one memorable building after another.

These new buildings were truly modern marvels in many ways. According to the *New York City Standard Guide* for 1901: "An office building is a city in itself, with its railway in the elevators, its water system, fire extinguishing apparatus on every floor, light, heat and power plants; post office and telegraph office, uniformed police force, restaurant, shops and a population running into the thousands. The tenant may supply his manifold wants without going from under the roof. He has at command telegraph, telephone and messenger service, and mails his letters in the mail chute, which extends through all the floors, carrying the letters to the mail box at the bottom, where the mail is collected by the postmen. He may lunch in the restaurant on one floor, take out a life insurance policy on another, cash his checks at his bank on a third, and put his valuables in safe-deposit in the basement. He may consult his physician, his broker or his lawyer; visit his tailor or shoeblack or barber; and buy his cigars, and paper, theater tickets, and flowers and a box of candy for his best girl."

Within 10 years of the Park Row Building (391 feet high, completed in 1899), the Singer Building (612 feet high, completed in 1908) rose to amazing new heights. The Woolworth Building (792 feet high) followed soon after. In fact, the Woolworth Building, financed by the dime store millionaire himself, was the tallest building in the world for 17 years.

By the late 1920s in Manhattan, soaring new office buildings of 300–500 feet in height were commonplace, as the population of the city increased dramatically. Also new to the skyline were massive hotels, such as the 40-floor Sherry-Netherland, the 43-floor Essex House, the 43-story Hotel New Yorker with its 23 elevators, and the towering 47-floor (and 625-foot-

high) Waldorf-Astoria. During the period between 1930 and 1940, though in the midst of the Great Depression, New York builders went ever higher, adding several more instantly beloved landmarks, including the art deco masterpiece Chrysler Building (for a few months the tallest building in the world), the towering Empire State Building (for decades the world's tallest building), and the impressive Rockefeller Center complex.

New York remained not only the skyscraper capital of the country, but also the skyscraper capital of the world for many years. As of 1950, in fact, 18 of the 20 tallest buildings in the world were located in New York City. During the years that followed, major skyscrapers began to spring up all around the world. As of the writing of this book, New York's tallest building, the Empire State Building, comes in at No. 14 among the tallest buildings in the world; 12 of the 13 buildings ahead of it on the list were completed after 1997.

Nonetheless, no other city can match the rich history, the incredible beauty, and the sheer number of skyscrapers that can be found in New York.

New York City postcards were issued for two basic reasons—to show off an impressive, pretty, or distinctive building or vista, or to serve as advertising and promotion for hotels, restaurants, and other establishments. Postcards are one of the most effective ways to promote tourism, and New York City postcards wound up in all corners of the world. Many people also collected postcards from all the places they visited, never intending to mail them. This book is meant to be a pictorial history of New York City's skyscrapers, but it is by no means a comprehensive representation of every important skyscraper in the city's history. I have tried to represent many of the major New York City skyscrapers built between 1885 and 1940.

The dates of the postcards, when given, are approximate. They usually represent the date of the postmark or sometimes the copyright date of the image. Often a date can be estimated based on the buildings shown in the image, though postcard publishers have been known to print cards in advance of a building's completion. A more general method of dating postcards is by their type. The earliest postcards featured undivided backs; the space for writing a message, if any, could be found on the front of the card. Linen cards were common during the 1930s and 1940s, and chromes (glossy color photographic cards) mostly after 1950.

In the early and mid-20th century, there were dozens of postcard publishers printing cards with New York City views. In many of the captions, I have noted the publisher. I have also noted the process, where that information is available. The specific type of paper, texture, and coating used on the postcard often had a name—Mirro-Krome, Plastichrome, and Lusterchrome are a few examples of different chrome postcard types. The process developer was sometimes one and the same as the publisher but sometimes not; Plastichrome cards, for example, were published by a number of different postcard publishers. There is a great deal more information available about postcard types and publishers. The Metropolitan Postcard Club of New York City is an excellent resource.

I have organized the book chronologically, for the most part by the year a particular structure was completed (regardless of the year the postcard was published). In the case of a general view of the skyline or of several buildings, I sort those by the approximate year of the image.

One

1626–1899

For hundreds of years after its founding in the early 17th century, the New York City skyline was modest, with the highest pinnacles being the city's many church spires. This began to change during the third quarter of the 19th century, as new building technologies allowed for the construction of higher structures. The late 1880s and early 1890s saw the construction of numerous buildings between 10 and 20 stories in height, the city's first real skyscrapers. At 391 feet high, the Park Row Building (completed in 1899) was the city's tallest for nine years. The exciting, impressive structures that were being built in New York at the close of the 19th century were the perfect subject matter for the many postcard publishers of the day; to visitors from elsewhere in the country, these tall buildings were true wonders.

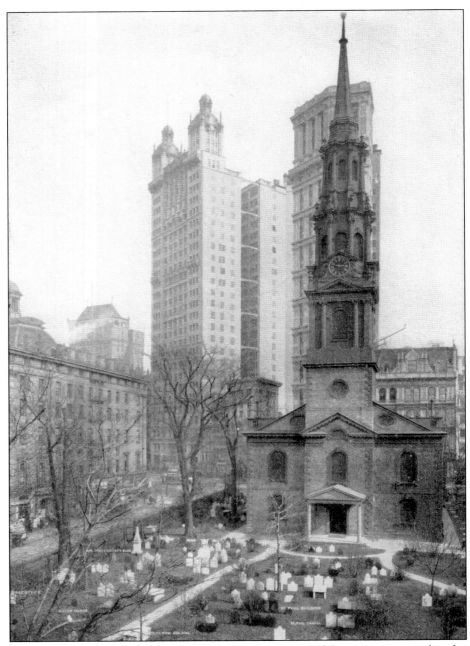

St. Paul's Chapel. From the 17th century through the end of the 19th century, church spires were the most prominent feature of the New York City skyline. St. Paul's Chapel (Episcopal) is the oldest surviving church in New York City that is still used for its original purpose, constructed in 1766 in the Georgian style. George Washington worshiped at St. Paul's. The church's spire rises nearly 150 feet high; by the end of the 19th century, it was dwarfed by its surroundings. In the background of this Irving Underhill image are the St. Paul building (right) and the Park Row Building (left). The church, located on Church Street between Fulton and Vesey Streets, was used as a command center following the September 11, 2001, attacks on the Twin Towers.

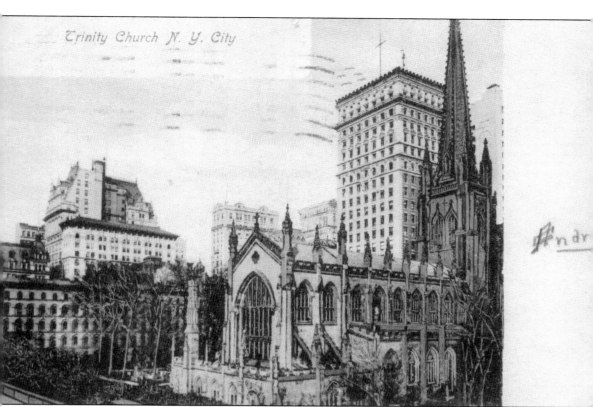

TRINITY CHURCH. Seen here at the beginning of the 20th century, the current Trinity Church (Episcopal) was built in 1846, the third church on the site. Designed by the noted architect Richard Upjohn, the stately church was the tallest structure in New York City for 44 years and is still one of the best-known (and most popular with tourists) churches in the city. Its spire rises 279 feet into the air.

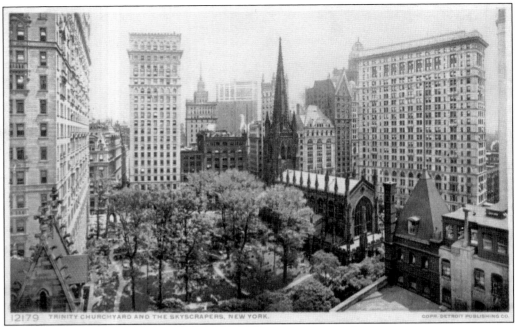

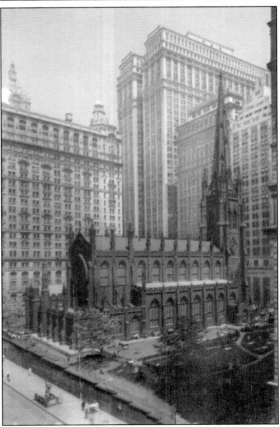

TRINITY CHURCHYARD AND SKYSCRAPERS. For decades after it was built, the spire of Trinity Church was the highest structure in the city. By the time this early-20th-century Phostint postcard (manufactured by the Detroit Publishing Company) was published, the church, located on Broadway at Wall Street, was becoming dwarfed by its surroundings.

TRINITY CHURCH AND EQUITABLE BUILDING. This 1960s Alfred Mainzer image shows Trinity Church surrounded by its early-20th-century skyscraper neighbors, including the distinctive twin shafts of the Equitable Building (described further in chapter two).

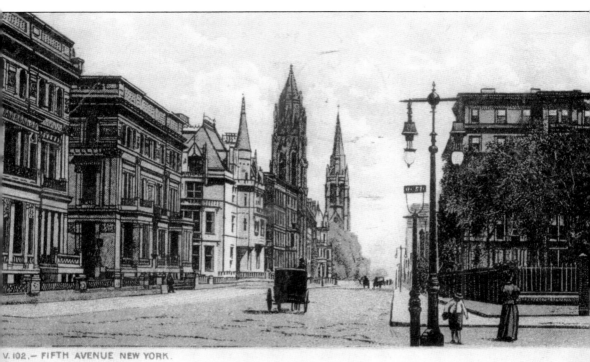

V. 102.— FIFTH AVENUE NEW YORK.

ST. THOMAS AND FIFTH AVENUE PRESBYTERIAN CHURCHES. Along Fifth Avenue in 19th-century Manhattan, church spires stood out gallantly among the mansions of the wealthy. This early-20th-century image of Fifth Avenue looking north from Fifty-first Street shows two examples. At center, the massive tower of the St. Thomas Episcopal Church at Fifty-third Street is visible. The church, the third on that site, was designed by Richard Upjohn and son and completed in 1870. The tower rose 260 feet above ground. Unfortunately, the elegant Gothic masterpiece burned to the ground in 1905; it was replaced with the fourth and current church. To the right of St. Thomas is the Fifth Avenue Presbyterian Church, located at Fifty-fifth Street. It was designed by Carl Pfeiffer and completed in 1875.

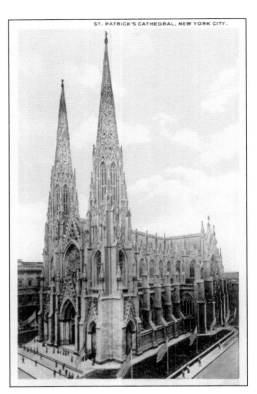

ST. PATRICK'S CATHEDRAL, NEW YORK CITY.

ST. PATRICK'S CATHEDRAL. One of the tallest structures in the city when built, St. Patrick's, perhaps the country's most famous Catholic church, has twin spires that rise to a height of 330 feet. Begun in 1858, the cathedral (located at Fifth Avenue and Fiftieth Street) was finally finished in 1879 after delays caused by the Civil War (1861–1865) and lack of funding.

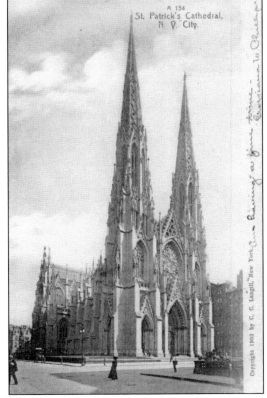

A 134
St. Patrick's Cathedral,
N. Y. City.

ST. PATRICK'S CATHEDRAL, 1902. Seen in this 1902 photo postcard, St. Patrick's Cathedral is currently dwarfed by the surrounding skyscrapers, but for many years, it stood out without any competition. The cathedral receives many thousands of visitors every year, and Mass on Christmas and Easter is especially crowded.

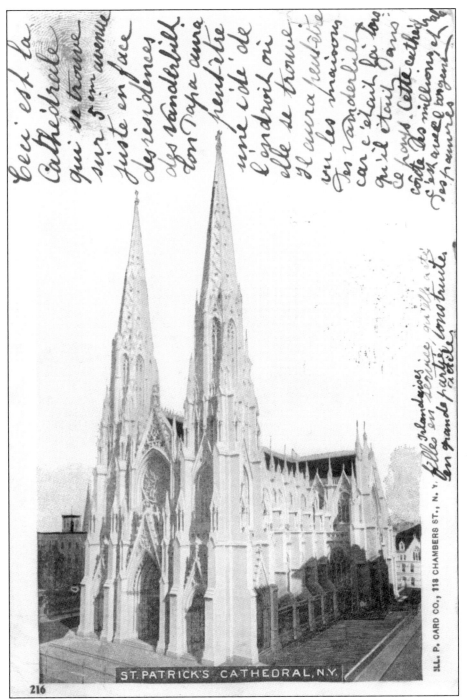

ST. PATRICK'S CATHEDRAL, N.Y.

216

ILL. P. CARD CO., 118 CHAMBERS ST., N. Y.

ST. PATRICK'S CATHEDRAL CARD TO FRANCE. This *c.* 1898 image of the cathedral is on a postcard mailed to France. The woman who signed the card wrote this message: "This is the Cathedral that is located on 5th Avenue just across from the Vanderbilt residence . . . this Cathedral cost millions and it is with the money of the poor Irish girls that the great majority was constructed."

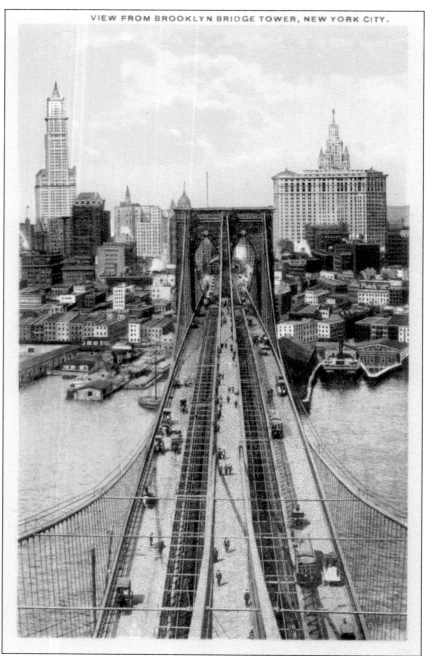

BROOKLYN BRIDGE. A German-born engineer named John Roebling designed the Brooklyn Bridge. After several decades in the works, the bridge finally opened to much fanfare in 1883. The bridge, the longest suspension bridge in the world when it opened, was the first to connect Brooklyn with Manhattan. The bridge resulted in continued growth and prosperity on both sides of the East River. The towers of the bridge rise 276 feet above the surface of the water. This *c.* 1915 American Art Publishing image shows the view of the New York skyline from the bridge tower.

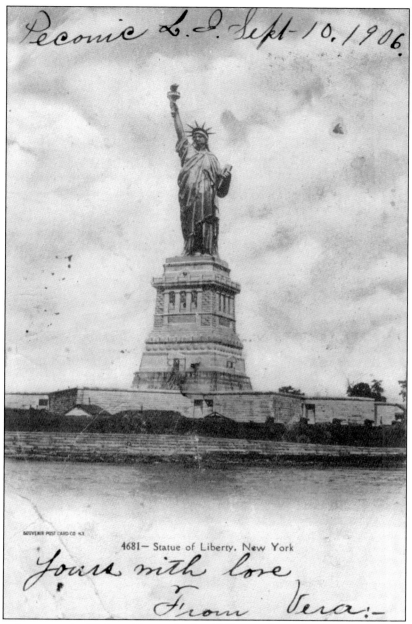

Peconic L.I. Sept 10, 1906.

4681— Statue of Liberty, New York

Yours with love
From Vera:-

STATUE OF LIBERTY. A gift from France in the 1880s, work on the Statue of Liberty actually began in 1871. Once all the pieces were cast, they were transported to the United States in numerous crates and assembled on Bedloe's Island (now known as Liberty Island) under the supervision of an army engineer named Charles Stone. The statue was designed by Frederic Bartholdi and engineered by Gustave Eiffel (the engineer of the Eiffel Tower). Its final height was 306 feet from the base of the pedestal to the tip of her torch. When completed, it was one of the highest man-made points in New York. The statue is still one of the most impressive and popular structures in the entire New York metropolitan area. It is located a little less than 2 miles south of Battery Park.

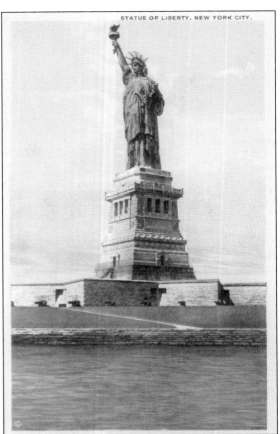

STATUE OF LIBERTY, NEW YORK CITY.

STATUE OF LIBERTY, 1906. Seen in a 1906 Souvenir Post Card Company image, the statue was closed for a $62-million restoration in 1984 and reopened in 1986 in time for its 100th anniversary. Liberty Island was closed for security reasons for nearly three years following the attacks on September 11, 2001, and finally reopened in 2004.

NEWSPAPER ROW. Newspaper Row, located near New York City Hall (and now known as Park Row), was so named because of the New York World, New York Tribune, and New York Times Buildings (seen from left to right) located there. At left is the Municipal Building. The 13-story Times Building (41 Park Row) was designed by George B. Post (architect of the World Building) and completed in 1889. This Irving Underhill image was published on an American Art Publishing postcard.

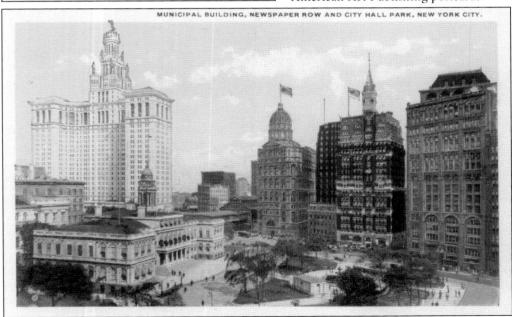

MUNICIPAL BUILDING, NEWSPAPER ROW AND CITY HALL PARK, NEW YORK CITY.

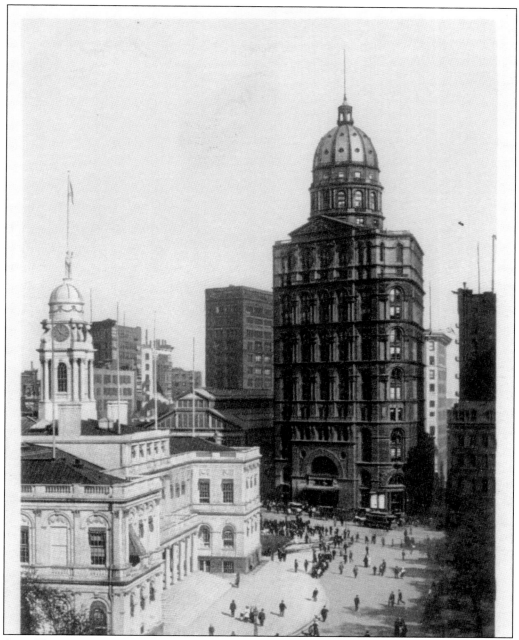

CITY HALL AND WORLD BUILDING. This postcard, dating to 1905, shows a view of the elegant gold-domed World Building. At 357 feet in height, the World Building (53 Park Row at the Brooklyn Bridge on Newspaper Row) was designed by George B. Post and completed in 1890. It was, for several years, the tallest building in New York City. The *World,* a newspaper started by Joseph Pulitzer in 1861, printed its last issue in 1931. The attractive building was unfortunately demolished in 1955 to make way for an automobile approach to the Brooklyn Bridge. This postcard was printed by the Detroit Publishing Company, one of the dominant postcard and photograph publishers of the early 20th century.

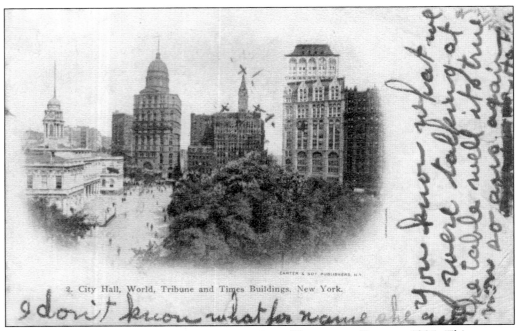

2. City Hall, World, Tribune and Times Buildings, New York.

[handwritten: you know what we were talking at the table well it's true now so goodbye again]

[handwritten: I don't know what for name she q]

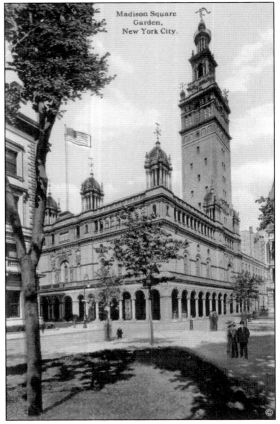

Madison Square Garden, New York City.

NEWSPAPER ROW, C. 1905. This undated Carter and Gut textured postcard shows, from left to right, New York City Hall and the Newspaper Row skyscrapers: the New York World, New York Tribune, and New York Times Buildings along Park Row.

MADISON SQUARE GARDEN. The first Madison Square Garden opened at Twenty-sixth Street and Madison Avenue in 1879. It was replaced in 1890 by a large $3-million structure that occupied an entire city block from Twenty-sixth to Twenty-seventh Streets between Madison and Fourth Avenues. The interior was 300 feet by 200 feet, had a height of 80 feet, and could seat 12,000 people. The tower was 341 feet high, making it the second highest structure in New York at the time of its construction. The second Madison Square Garden closed in 1924, and the third Madison Square Garden was located on Eighth Avenue and Forty-ninth Street. The current Garden is located at Seventh Avenue and Thirty-second Street.

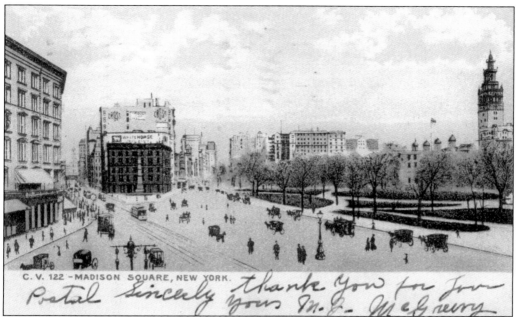

C. V. 122 – MADISON SQUARE, NEW YORK.

Postal Sincerely thank you for you yours M.J. McGrury

MADISON SQUARE. In this 1907 view of Madison Square, the tallest structure visible is the tower of the old Madison Square Garden, far right. Now known as Madison Square Park, it is located between Fifth and Madison Avenues from Twenty-third to Twenty-sixth Streets and opened in 1847. The Garden left the area long ago, but the square's name still remains.

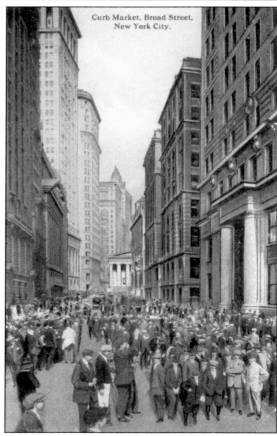

Curb Market, Broad Street, New York City.

CURB MARKET IN BROAD STREET LOOKING TOWARD WALL STREET. The narrow streets of lower Manhattan were laid out in the 17th and early 18th centuries. With the construction of downtown skyscrapers was born the distinctive "canyons of lower Manhattan." By 1914, the postmark date of this American Art card, the canyon effect was already evident.

UNION SQUARE. At the time this Arthur Strauss postcard scene was captured in 1896, the tallest buildings in New York City were the World Building and the Manhattan Life Insurance Building, both 348 feet high. As can be seen from this view, most of the "tall" buildings in the city only reached a height of 10–15 stories. The Decker Building (see caption below) is at left.

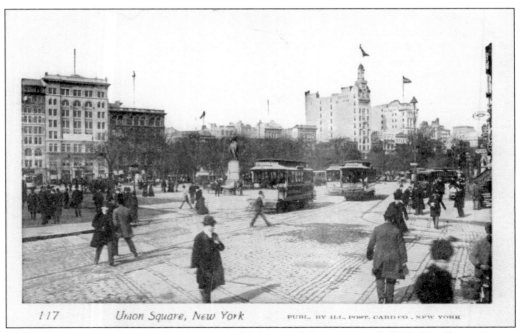

UNION SQUARE AND DECKER BUILDING. In this image, dating to around 1905, the tallest structure is the Decker Building. Built in 1892 for the Decker Brothers Piano Company, the 11-story Decker Building (also known as the Union Building) is only 33 feet wide. It was where the artist Andy Warhol's Factory was located for several years in the late 1960s and early 1970s.

HOME LIFE INSURANCE BUILDING.
When completed in 1894, the Home
Life Insurance Building (designed by N.
LeBrun and Son) was one of the tallest
buildings in New York. At 287 feet
high and 16 stories, the building at 256
Broadway, between Warren and Murray
Streets, included four elevators and had
56,000 square feet of rentable space. The
interior was destroyed by fire in 1898,
but the exterior survived. This image was
published by the Rotograph Company.

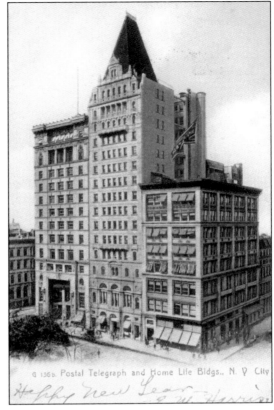

a 156b. Postal Telegraph and Home Life Bldgs., N. Y. City

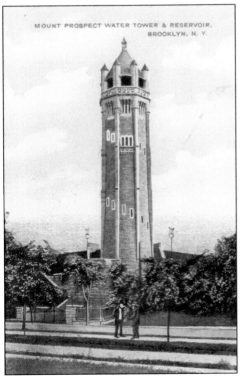

MOUNT PROSPECT WATER TOWER & RESERVOIR,
BROOKLYN, N. Y.

MOUNT PROSPECT WATER TOWER. The
Mount Prospect Water Tower was built
around 1894 adjacent to a 20-million-gallon
reservoir and was once one of the most distinct
features of the Brooklyn skyline. The tank
within the water tower was composed of 15
rings of high-grade boiler iron, with a tensile
strength of over 51,000 pounds to the square
inch. The tank was supported on a flooring of
steel girders, which rested on masonry piers,
the bottom being 34 feet 7 inches above the
concrete foundation. Seen in a *c.* 1908 German-
printed postcard, the 75-foot-high tower was
demolished in 1935, along with the reservoir,
and is now the site of Mount Prospect Park.

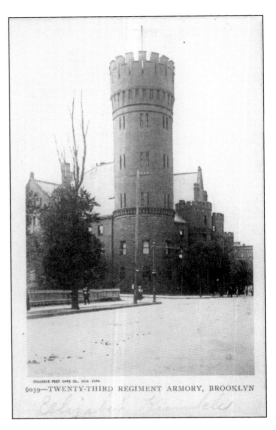

6039—TWENTY-THIRD REGIMENT ARMORY, BROOKLYN

THE 23RD REGIMENT ARMORY. This structure looks like a medieval fortress with several circular towers, the tallest of which rises an impressive 136 feet. Completed in 1895, the armory was designed by the firm of Fowler and Hough. Located on the block of Bedford Avenue, Franklin Avenue, Pacific Street, and Atlantic Avenue in Brooklyn, the armory is seen in this pre-1907 postcard image.

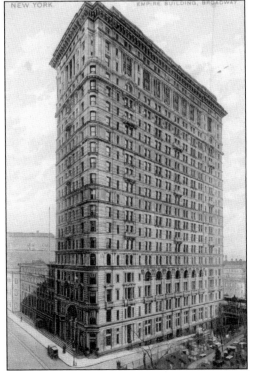

EMPIRE BUILDING. This building, located at 71 Broadway (at the southwest corner of Rector Street near Wall Street), was one of the early skyscrapers of New York, designed by Kimball and Thompson and built in 1897–1898. At 320 feet high, it had 25 floors serviced by 10 elevators. A workforce of 2,200 could be employed here. The granite used in the building came from the Mount Waldo Granite Works in Frankfort, Maine.

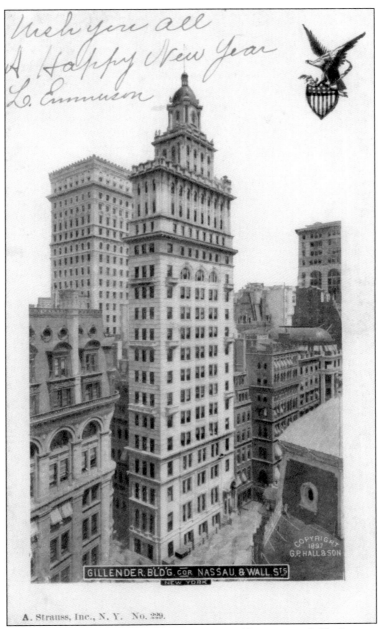

Wish you all
A Happy New Year
L. Emmerson

GILLENDER BLD'G. COR NASSAU & WALL STS
NEW YORK

COPYRIGHT 1897 G.P. HALL & SON

A. Strauss, Inc., N. Y. No. 229.

GILLENDER BUILDING. The Gillender Building, designed by Berg and Clark, was completed in 1897. At 273 feet high, the 20-story structure was among the tallest buildings in New York City when built. The foundation material consisted of fine, loose, wet sand, so pneumatic caissons had to be used, covering about three-fifths of the area of the site. Each caisson supported four columns, or two on either side of the building. These were proportioned to distribute the loads at 12 tons per square foot. Shown here in an 1897 G. P. Hall and Son image published by A. Strauss, the narrow building was demolished in 1910 and replaced with the much taller Bankers Trust tower. According to a 1910 *New York Times* article, it was the first time a "high class office building" was torn down to make way for a more elaborate structure.

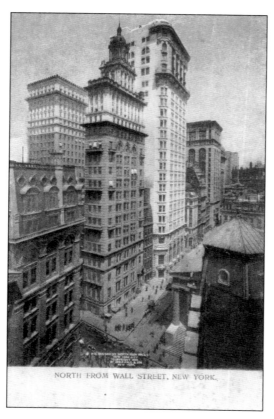

NORTH FROM WALL STREET, NEW YORK.

NASSAU STREET, NORTH FROM WALL STREET. This 1903 copyrighted image featuring the Gillender Building was on a postcard that was mailed from Vermont in 1936, long after the Gillender Building was demolished. There are two possible explanations for instances such as this—first, people may keep unused postcards for many years before mailing them, and second, some postcards are sold for many years after being published.

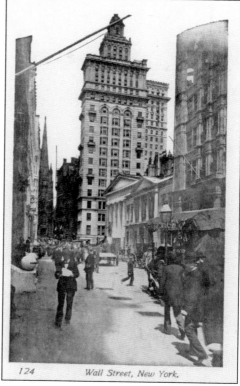

124 Wall Street, New York.

WALL STREET WITH GILLENDER BUILDING. The Gillender Building was the star of early Wall Street postcards, as the tallest and most distinctive of the early skyscrapers in the area. This undated photo postcard published by the H. L. Post Card Company around 1905 shows the impressive structure.

WALL STREET WITH GILLENDER AND TRINITY. Here is another view of Wall Street, this one showing the Gillender Building at right and Trinity Church to its left, on a postcard postmarked in 1912.

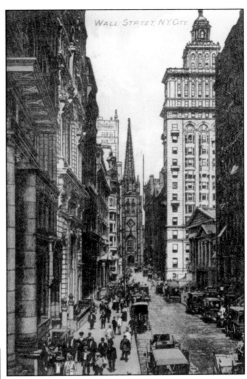

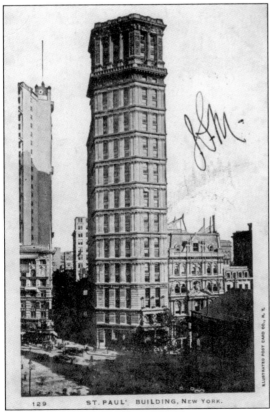

ST. PAUL BUILDING. Seen in this *c.* 1906 Illustrated Post Card Company image, the St. Paul Building, located at 220 Broadway, was built in 1898. At 24 stories, it was 315 feet high. The smaller offices in the building were 10 feet wide by 20 feet long; those facing the elevator were 25 feet long. There were six fast-running elevators. Located across from the famous St. Paul's Chapel, the building was demolished in 1958.

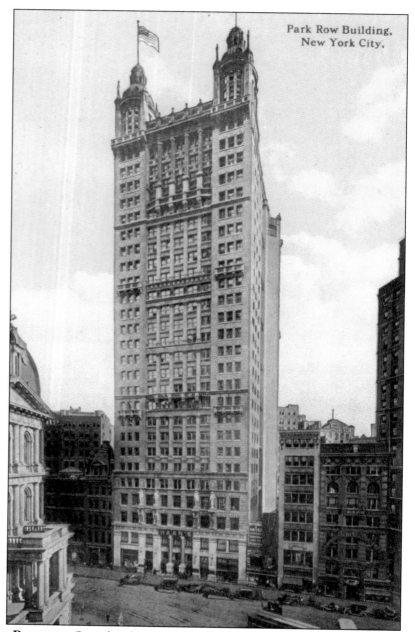

PARK ROW BUILDING. Completed in 1899, the 381-foot-high Park Row Building (also known as 15 Park Row) was the tallest building in New York for nine years. Built of limestone, the building has 29 floors, 200,000 square feet of space, and faces City Hall Park. The builder was August Belmont, and the structure cost $3.5 million to construct. The Park Row Building was the tallest building in the world from its completion until the 1908 completion of the Singer Building. The weight of 20,000 tons is carried on 4,000 piers driven into the sand 40 feet down to bedrock. The cost of building and land was $2.4 million. At its completion there were 950 offices, 2,080 windows, 1,770 doors, and 7,500 electric lights. The 10 elevator cars traveled 16.38 miles and carried an average of 814 persons an hour, or 8,140 a day, or 48,860 a week.

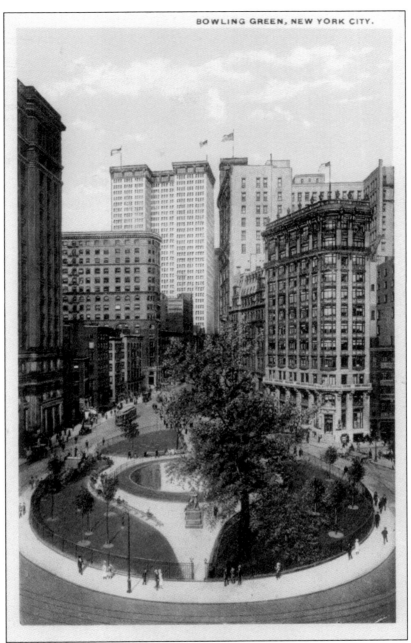

BOWLING GREEN BUILDING. The area around Bowling Green, one of the city's oldest public spaces, near the southernmost tip of Manhattan Island, has been a center for commerce since the 1600s. The building at left is the 16-story, 224-foot-high Bowling Green Building, designed by the Audsley Brothers and completed in 1898. The Bowling Green Building had a coal storage capacity of 420 tons and required 6,000 lights. Other early skyscrapers in the area included the Standard Oil Building (26 Broadway, not seen in the image). Today there are even more skyscrapers crowded around Bowling Green, including 2 Broadway (32 floors, built in 1960 and renovated in 1999), among others. This American Art Publishing Company postcard dates to 1915.

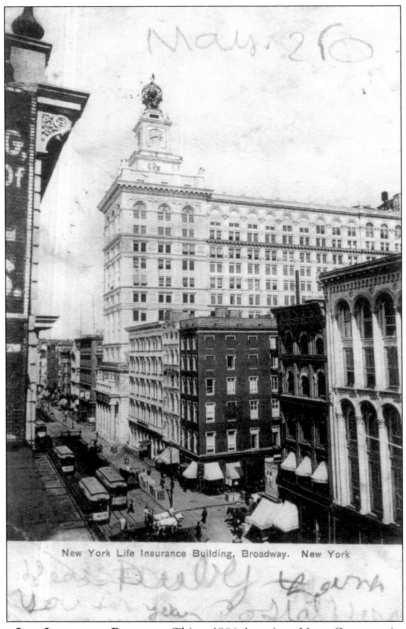

New York Life Insurance Building, Broadway. New York

NEW YORK LIFE INSURANCE BUILDING. This *c.* 1906 American News Company image shows the original New York Life Building, located at 346 Broadway between Leonard and Lafayette Streets. The company (later known as Metropolitan Life) moved to new headquarters in 1923, a 617-foot-high building at Madison Square. The building, completed in 1898, was designed by McKim, Mead, and White. It offered 325,000 square feet of space. The columns of polished marble were 27 feet in height. The clock tower was, at the time, a conspicuous feature of the area. The Merchants' Association had headquarters in the building, and its guests received admission tickets to the tower of the building. The 13-story building is 288 feet high to the top of the eagle.

Two

1900–1911

By 1901, there were nine buildings in New York City 300 feet or more in height and 26 buildings at least 200 feet in height. Those numbers, however, would soon be dwarfed; the skyline of New York received a major addition in 1908 with the construction of the 612-foot-high Singer Building. The first decade of the 20th century also saw the construction of the iconic, wedge-shaped Flatiron Building at Twenty-third Street and Fifth Avenue, the massive City Investing Building at Broadway and Cortland Street near the Singer Building, the famous Plaza Hotel at Fifty-ninth Street and Fifth Avenue, and the Theater District landmark Times Building.

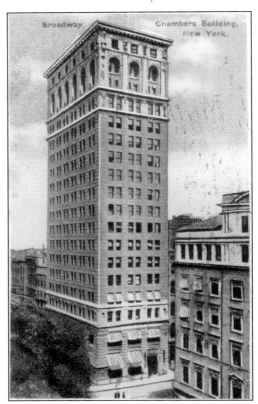

BROADWAY CHAMBERS BUILDING. Begun in 1899 and completed in 1900, the Chambers Building (277 Broadway) was designed by the famous architect Cass Gilbert, who later designed the Woolworth Building. The building, seen on a 1915-postmarked card, was one of the most prominent buildings in the city when completed. The base was made of granite, the building itself brick, and the top copper.

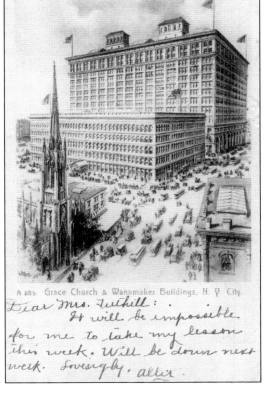

A 885 Grace Church & Wanamaker Buildings, N. Y. City.

Dear Mrs. Tuthill:
It will be impossible for me to take my lesson this week. Will be down next week. Sovereignty, after.

WANAMAKER BUILDING. The Wanamaker Department Store was located at Fourth Avenue and East Ninth Street. Alexander Stewart built the five-story building to the left of the taller structure as a department store in 1862. Wanamaker's acquired the store and built the adjacent structure in 1902. The original building was demolished in 1956, but the annex still stands. In the foreground is Grace Church, built in 1845 and designed by James Renwick Jr.

THE FLATIRON BUILDING. Daniel Burnham, a Chicago architect, designed this Beaux-Arts structure. It was originally known as the Fuller Building but was given its more popular name due to its narrow triangular shape. It was the first steel-frame skyscraper in the world. Completed in 1902, it stands at Twenty-third Street at the intersection of Broadway and Fifth Avenue. At 22 stories and 300 feet high, it contains a total of 133,000 square feet of space.

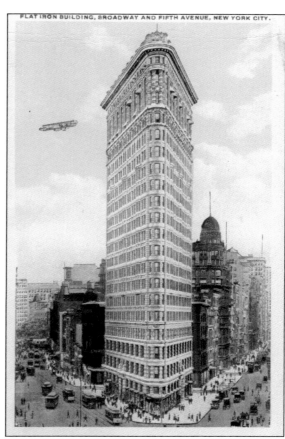

FLATIRON BUILDING, BROADWAY AND FIFTH AVENUE, NEW YORK CITY.

WILLIAMSBURG BRIDGE. Seen on a Success Postal Card, the Williamsburg Bridge between Manhattan and Brooklyn was opened in 1903. The towers rise 335 feet above the East River. The total length of the bridge is over 7,000 feet; the main span is 1,600 feet long. At the time of its completion, it was the longest suspension bridge in the world.

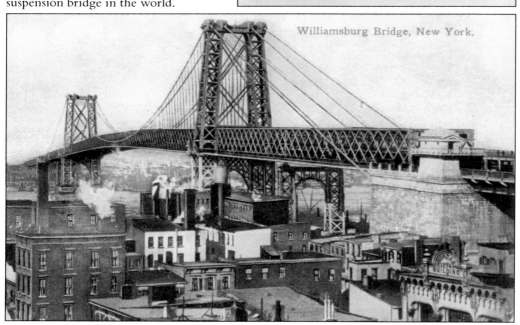

Williamsburg Bridge, New York.

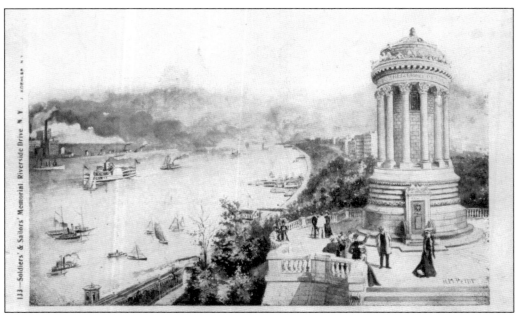

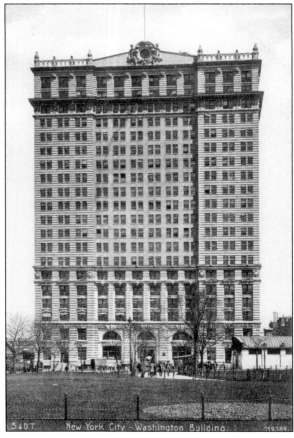

SOLDIERS' AND SAILORS' MONUMENT.
Though only 96 feet high, this monument, completed in 1902, sits atop a high vantage point along Riverside Drive at Eighty-ninth Street in Manhattan and so is visible from a distance. The monument was dedicated to those who died in the Civil War. This early postcard view by Joseph Koehler dates to the 1890s.

WHITEHALL BUILDING, ORIGINAL.
Located at 17 Battery Place (at the northeast corner of West Street extending to Washington Street), this building was constructed in two parts. Originally known as the Washington Building, the older section was completed in 1903 and is seen here in a Schaar and Dathe German-printed postcard view taken before the addition was built. The architect for the original segment was Clinton and Russell. The original segment stands at 259 feet high.

HANOVER BANK BUILDING. This structure, completed in 1903, was the Gillender Building's neighbor and then the Bankers Trust Building's neighbor after that structure replaced the Gillender Building in 1912. In 1919, Bankers Trust acquired the Hanover Bank property, and in 1931, the Hanover Building was demolished and replaced with an addition to the Bankers Trust Building. (Library of Congress.)

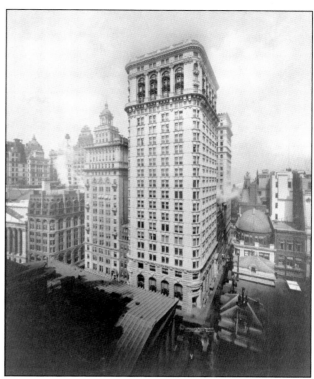

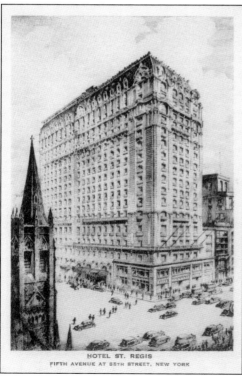

HOTEL ST. REGIS
FIFTH AVENUE AT 55TH STREET, NEW YORK

HOTEL ST. REGIS. Designed by Trowbridge and Livingston and financed by John Jacob Astor, the Beaux-Arts Hotel St. Regis was completed in 1904. It was the highest hotel in New York City at the time. The building was added to in 1927; Sloan and Robertson designed the extension. The 255-foot-high Hotel St. Regis featured 22 floors with 650 guest rooms. Located at Fifth Avenue and Fifty-fifth Street, the hotel remains today as one of the landmark skyscrapers of New York.

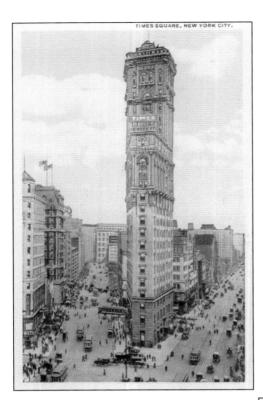

TIMES SQUARE, NEW YORK CITY.

TIMES BUILDING AND TIMES SQUARE.
The Times Building was built at Forty-second Street and Broadway in 1905. At 362 feet high, it had 27 stories and was one of the most impressive of the early New York City skyscrapers. The *Times* moved to a new building on West Forty-third Street in 1913. It is now headquartered at a brand new, 52-story, 748-foot-high (not counting the antenna) building on Eighth Avenue and Fortieth Street.

TIMES BUILDING DECORATED POSTCARD.
This 1920 postmarked postcard of the Times Building is decorated with stripes of multicolored glitter and was published by the Photo and Art Post Card Company. It shows how the building stood out next to its smaller neighbors. Designed by Eidlitz and McKenzie, the building featured an attractive Beaux-Arts facade. The original building still stands, but it is now completely unrecognizable as it is clad in a modern facing. Its main purpose today is to hold giant billboards, which disguises it further; a drugstore currently occupies the first three floors.

PUB. BY
PHOTO. & ART P. C. CO., N. Y.
THE NEW YORK TIMES
NEW YORK

TIMES BUILDING. This photograph of the Times Building in Times Square was taken around 1928 by a recently arrived German immigrant. The very same buildings that were featured on postcards were those that camera-bearing visitors and residents alike were bound to photograph for themselves.

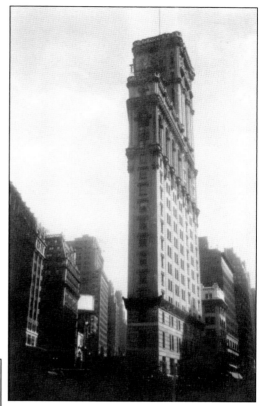

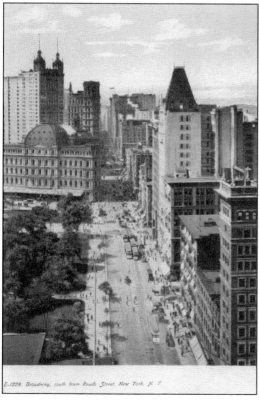

E-1228. Broadway, south from Reade Street. New York. N. Y.

BROADWAY SOUTH FROM READE STREET. This *c.* 1905 German-made view shows some of the early skyscrapers in the area. At right center is the Home Life Insurance Building (with triangular cupola). At far left, the towers of the Park Row Building are visible.

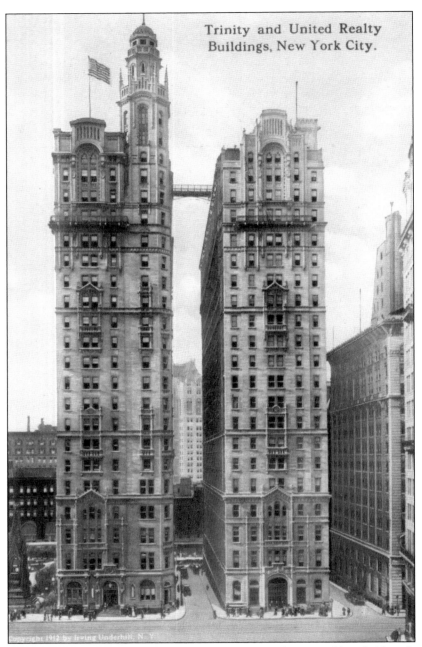

Trinity and United Realty
Buildings, New York City.

Copyright 1912 by Irving Underhill, N. Y.

Trinity Building and United States Realty Building. Connected by a bridge, the adjacent buildings at 111 Broadway and 115 Broadway were designed by Francis H. Kimball and completed in 1905. The structures had 23 floors, and the Trinity Building, with its attractive cupola, rose to a height of 308 feet. Combined, the two buildings had 552,000 square feet of space. For the foundations of the United States Realty Building, there were 87 caissons sunk to bedrock 75 feet below the surface, and all were finished in 60 days, a world record. Before that, the record was held by the Trinity Building, where 50 caissons were completed in 57 days. The 87 United States Realty Building caissons cost a total of $500,000, or a little less than $6,000 each.

FULLER BUILDING. This is not the same Fuller Building more commonly known as the Flatiron Building but a different one. This 28-story, twin-cupola structure is depicted around 1905. There were several buildings with the Fuller name in New York, including the landmark structure at 41 East Fifty-seventh Street built in 1929.

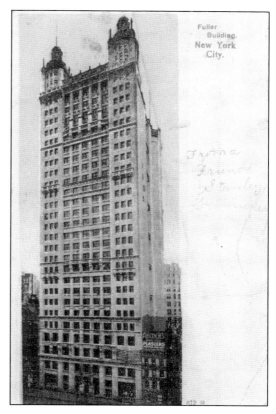

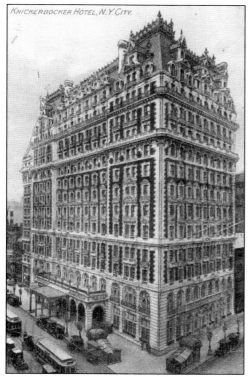

KNICKERBOCKER HOTEL. The Knickerbocker was a popular hotel during the early 20th century. Located at 1466 Broadway, southeast corner of Forty-second Street, the 15-story building was completed in 1906. It could accommodate 1,000 guests with 556 sleeping rooms and 400 bathrooms; the restaurant's capacity was 2,000. The Beaux Arts–style building is seen here around 1911. It was later known as the Newsweek Building.

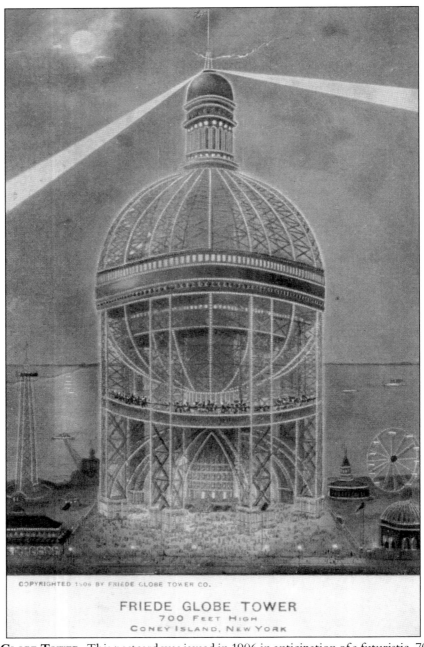

FRIEDE GLOBE TOWER
700 FEET HIGH
CONEY ISLAND, NEW YORK

FRIEDE GLOBE TOWER. This postcard was issued in 1906 in anticipation of a futuristic, 700-foot-high, 300-foot-diameter steel tower that was to be built at Coney Island. The giant globe was to include a roof garden, restaurant, and theater 150 feet up, an aerial hippodrome at 250 feet, a café and dance hall at 300 feet, a garden at 400 feet, an observatory platform at 500 feet, and still further up a branch of the Weather Bureau. The cost was originally estimated at $973,000. The tower was the brainchild of Samuel Friede, who organized the Friede Globe Tower Company to get investors to put money into the scheme. The tower was never built, and it was later determined that the scheme was a fraud. The company treasurer was convicted of embezzlement.

STOCK EXCHANGE. The narrow streets of lower Manhattan, first laid out hundreds of years ago, were originally quaint when the buildings were on a small scale. With the construction of skyscrapers beginning in the early 20th century, the "canyon" effect was created, as seen here in this undivided back postcard of the Stock Exchange Building, surrounded on all sides by much taller structures.

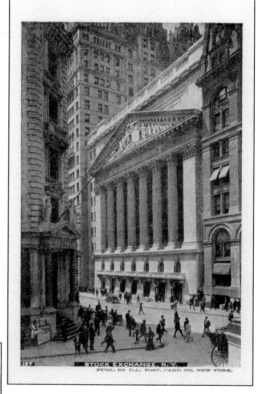

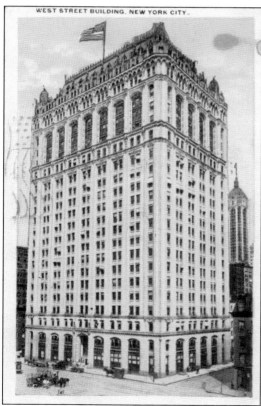

WEST STREET BUILDING. The steel, terra-cotta, and granite West Street Building, located at 90 West Street (Cedar to Albany Streets), was built in 1907. At 307 feet high, the 24-floor structure (with 234,000 square feet of office space) was an imposing presence on the west side of lower Manhattan. Cass Gilbert, who would later serve as architect of the Woolworth Building, designed the copper-roofed structure. The building was damaged by debris during the September 11, 2001, attacks but has since been restored. This Century Post Card and Novelty Company postcard calls it "one of the handsomest and most absolutely fireproof buildings in the world."

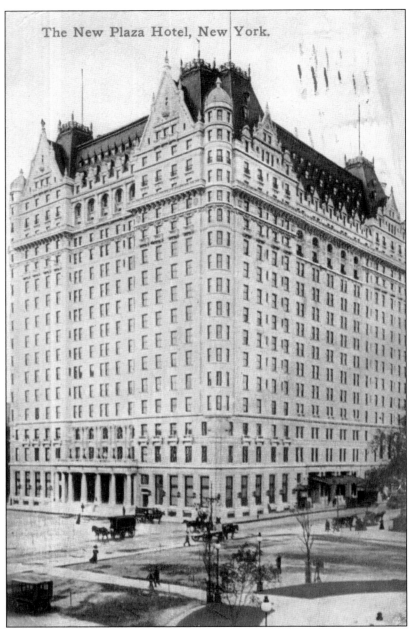

The New Plaza Hotel, New York.

PLAZA HOTEL. Originally built in 1907 and added to in 1921, the Plaza Hotel has long been one of the most famous hotels in the city. The 20-floor building rises 290 feet high. With its addition, it had 1,098 guest rooms and 12 elevators. Seen in this *c.* 1910 postcard, the Plaza is located on Fifth Avenue between Fifty-eighth and Fifty-ninth Streets at the Grand Army Plaza, adjacent to the southeast corner of Central Park. It was designed by Henry Hardenbergh, who also created the famous Dakota apartment building on Central Park West where John Lennon lived. The Plaza Hotel can be seen in numerous movies and is the setting of the famous Eloise series of children's books. It was recently renovated and turned into a combination hotel/residential space.

APPROACH TO BROOKLYN BRIDGE. This *c.* 1908 Phostint Detroit Publishing postcard shows the attractive view of the New York skyline that could be had by those crossing the bridge. With every passing year, the view became more impressive.

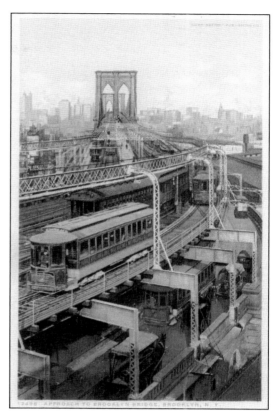

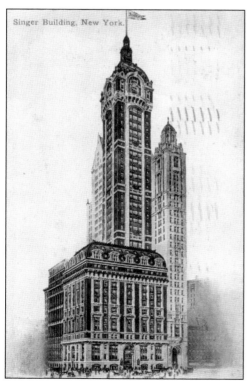

SINGER BUILDING. Completed in 1908, the Singer Building was constructed by the Singer Manufacturing Company (makers of sewing machines). Located at Broadway and Liberty Street, it rose 47 floors for a height of 612 feet. The foundations were 36 caissons sunk to the bedrock 92 feet underground. The observation balcony was soon given the nickname "Suicide Pinnacle" because of some people's proclivity to jump upon reaching the top. It was the tallest building in the world until the completion of the Metropolitan Life Building a year later. This Success Postal Card Company image dates to around 1911.

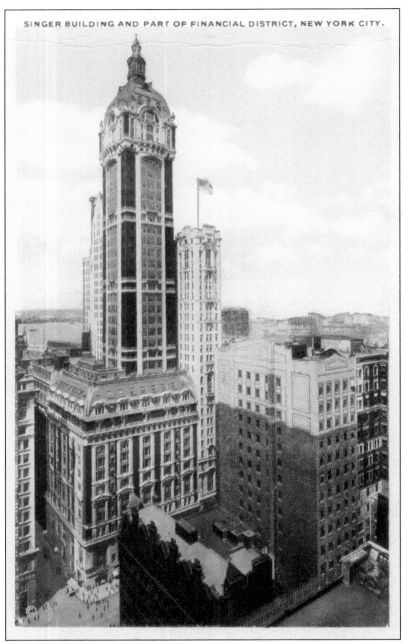

SINGER BUILDING AND PART OF FINANCIAL DISTRICT, NEW YORK CITY.

SINGER BUILDING AND PART OF FINANCIAL DISTRICT. Not only was the Singer Building for many years one of the tallest buildings in New York, it was also a colorful and attractive structure, with materials such as red brick, white stone, and green copper combining for a happy marriage of hues. Designed by Ernest Flagg, the tower rose 421 feet above the main building and was 65 feet on all sides. When fully occupied, 5,000 tenants worked in the building, brought to their offices by 16 elevators. This 1912 colorized photograph was copyrighted by Irving Underhill (whose popular photographs wound up on many early-20th-century postcards) and printed by the American Art Publishing Company.

HHT Company Image of Singer Building.
Here is another very similar view of the
Singer Building, also from 1912, published
by the HHT Company. Six of the building's
47 stories were located within the cupola. It
was demolished in 1968 and replaced with the
U.S. Steel Building (later One Liberty Plaza).

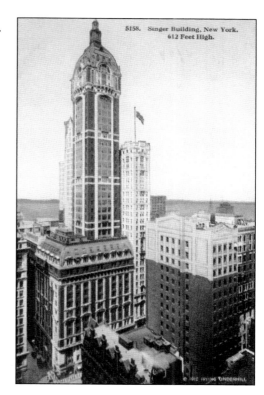

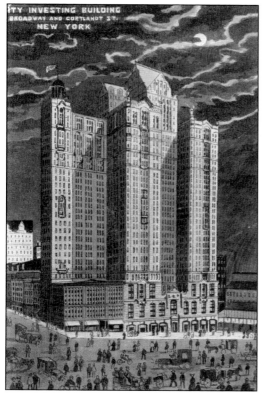

City Investing Building. Located at
Broadway and Cortland Street, the City
Investing Building was 487 feet high with
33 floors. Designed by Francis H. Kimball,
it had 23 elevators. The interior woodwork
was mahogany. It is shown in this postcard
view against the backdrop of an ominous
night sky around 1912. The City Investing
Building was completed in 1908 and
demolished in the 1960s at the same time as
its neighbor, the famous Singer Building.

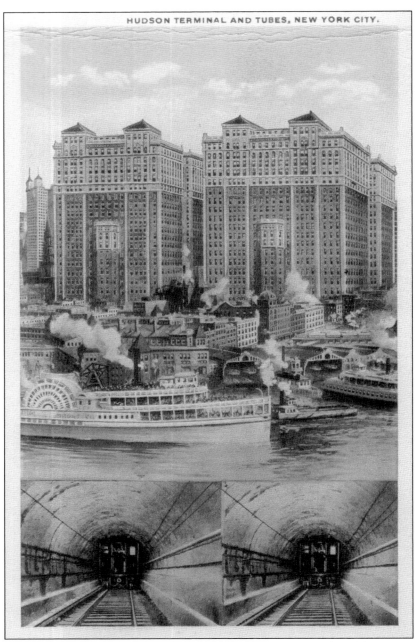

HUDSON TERMINAL BUILDINGS. The massive 22-story Hudson Terminal Buildings (375 feet high and estimated to weigh 200,000 tons) on Church Street between Cortland and Fulton Streets were built in 1908 on a cofferdam 440 feet by 178 feet, 75 to 98 feet deep. Clinton and Russell designed the buildings. There was space for 20,000 office workers; when built, it represented the largest office building complex in the world. The site was also a rail terminal where the twin train tubes let passengers off from New Jersey. Ironically, these impressive twin structures were destroyed in the 1960s to make room for another pair of twin structures, the Twin Towers of the World Trade Center.

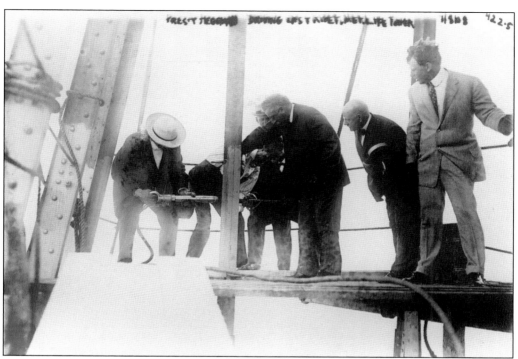

METROPOLITAN LIFE BUILDING. This photograph shows the driving of the last rivet for the Metropolitan Life Building's (also known as the Metropolitan Life Tower or the Met Life Tower) steel framework in July 1908. Located at Madison Square between Twenty-third and Twenty-fourth Streets, the building was an addition to the existing 12-story structure that was built in 1893. (Library of Congress.)

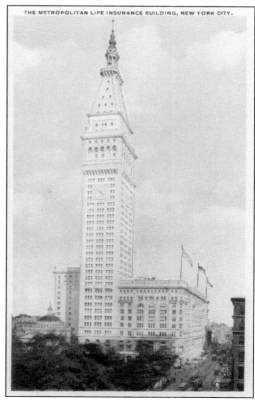

METROPOLITAN LIFE TOWER. Completed in 1909, the Metropolitan Life Building replaced the Singer Building as the tallest in the world. At 700 feet high, it has 50 floors and over 1 million square feet of usable space. The architect of the marble-faced structure was Napoleon LeBrun and Sons.

47

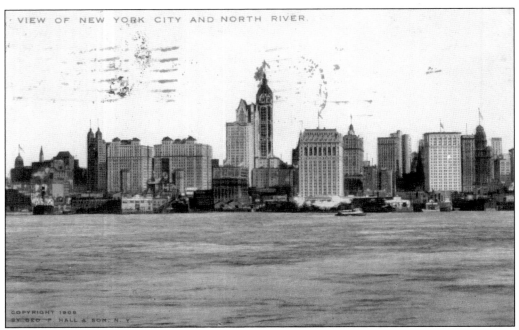

COPYRIGHT 1909
BY GEO P. HALL & SON, N.Y.

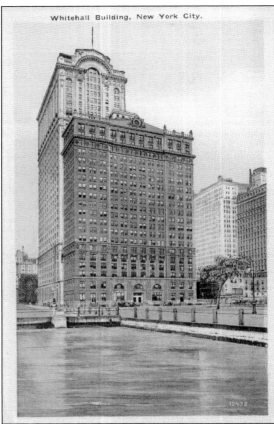

Whitehall Building, New York City.

12432

SKYLINE FROM HUDSON RIVER. The Hudson River was still sometimes called the North River, a term that dated back to Colonial days. In this 1909 Theochrom image, the Singer Building alone ruled the New York City skyline. Just a few years later, it would be dwarfed by the Woolworth Building. A little to the left of the Singer Building are the newly constructed Hudson Terminal Buildings.

WHITEHALL BUILDING WITH ADDITION. The newer part of the Whitehall Building was constructed in 1910 and is 416 feet high with 32 stories; in total, the building contains 545,000 square feet of space. Tenants once included Quaker Oats and the Gulf Refining Company.

WHITEHALL BUILDING, 1930s. This 1930s postcard shows the original and addition buildings together. The building contained "some of the most exclusive clubs in the city," according to the postcard caption. The United States Weather Bureau had its local station on the roof.

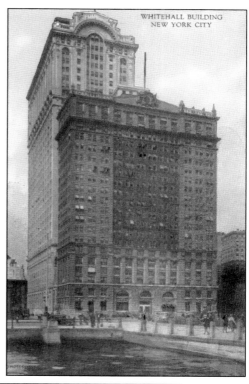

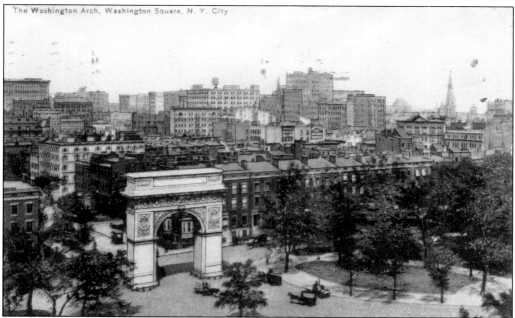

WASHINGTON ARCH AT WASHINGTON SQUARE PARK. Soil conditions (the greater distance from surface to bedrock) do not allow for the same degree of tall buildings in the Washington Square/Union Square area as in lower and midtown Manhattan. It is evident in this *c.* 1910 image and still holds true today.

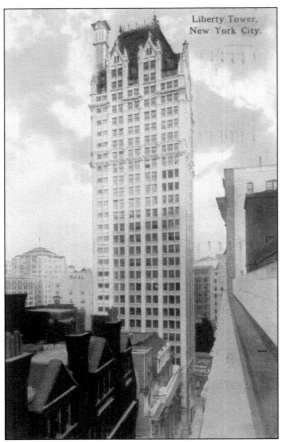

Liberty Tower,
New York City.

LIBERTY TOWER. Located at 55 Liberty Street at the northwest corner of Liberty and Nassau Streets in downtown Manhattan, the Liberty Tower was completed around 1909. The 31-story, 401-foot-high limestone building, designed by Henry Ives Cobb, is clad in white terra-cotta and sits on a plot measuring 58 feet by 82 feet. The office tower, seen in this *c.* 1915 American Art Publishing postcard, was converted into residential use in 1980. The conversion architect was Joseph Pell Lombardi. It was made into 64 simplex, duplex, and triplex co-op apartments, originally selling for between $56,000 and $220,000. The building is designated as a New York City Landmark.

EAST RIVER FRONT. The skyline of lower Manhattan is seen in an undated A. C. Bosselman postcard. The early skyscrapers in this image may not seem very impressive by today's standards, but they were at the time some of the tallest buildings in the world. With each passing year, technology was improving, allowing taller and more elegant structures to be constructed.

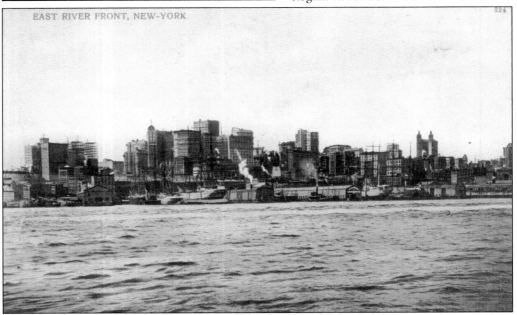

EAST RIVER FRONT, NEW-YORK.

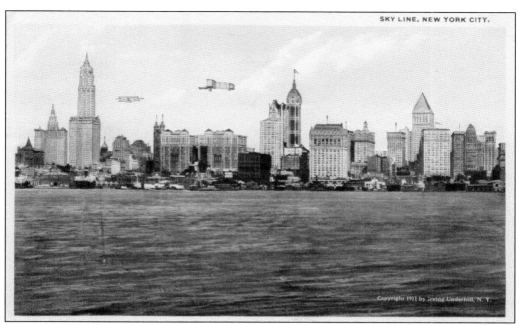

Copyright 1911 by Irving Underhill, N. Y.

SKYLINE FROM JERSEY CITY. These are two nearly identical views taken from Jersey City by Irving Underhill. The tallest building, at left, is the Woolworth Building. Also visible are the Singer Building and the Banker's Trust Building (triangular roof). The photograph below was taken slightly later than the one above, which is copyrighted 1911 (before the Woolworth Building or Banker's Trust Building were actually completed). Note the key differences: the older image shows two airplanes in the sky and the newer image shows three ships in the water, as well as two new additions to the New York skyline. At the time these postcards were published, the population of Manhattan was 2,331,542. Thanks to the growing number of skyscrapers, lower Manhattan's office population had reached 400,000, with land there worth between $200 and $600 per square foot and rents between $1 and $40 per square foot.

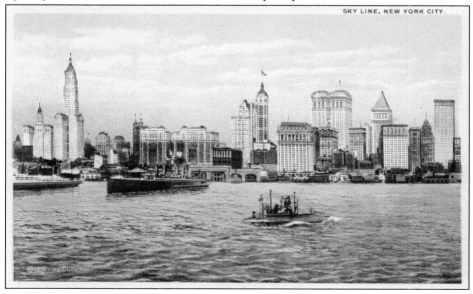

51

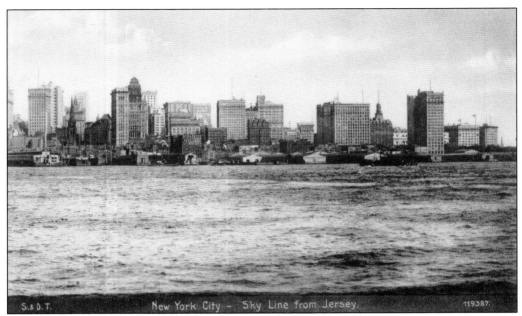

SKYLINE FROM JERSEY. Skyline postcards can be deceiving because building heights are relative. In this early-20th-century image, the main visual clue is that behind Trinity Church (at left) the Gillender Building is still visible, definitively dating this German-printed Schaar and Dathe card to pre-1910. The Gillender Building's replacement, the Bankers Trust Building, would dwarf the rest of the structures in this image at about twice the height of the Gillender Building.

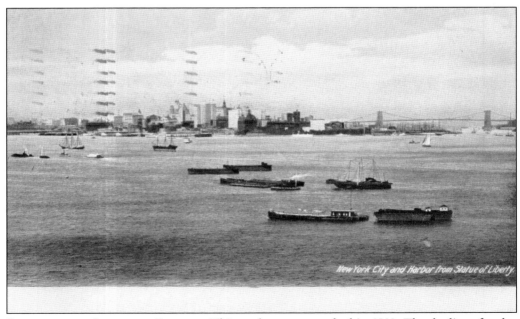

SKYLINE FROM STATUE OF LIBERTY. This card was postmarked in 1911. The duality of early-20th-century New York City can be seen in this image—the modern technological wonder of skyscrapers in contrast to the simple sailboats in the harbor.

Three

1912–1929

The 1910s and 1920s saw the construction of several iconic skyscrapers, including the Woolworth Building, the city's tallest building, and the elegant Municipal Building. This period was also a boom time for the construction of new hotels. With the growing popularity of the automobile and the construction of both Grand Central Terminal and Pennsylvania Station, more tourists were visiting New York than ever before. Accordingly, the postcard business boomed, and New York's skyscrapers were featured in many of them. Other developments of the time included a 1916 local law declaring that New York City's skyscrapers must have setbacks (reduced area compared to the ground floor area) in order to ensure that sunlight could reach the city streets.

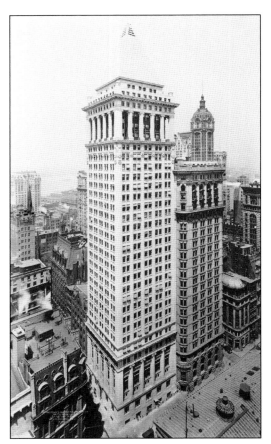

BANKERS TRUST BUILDING. Completed in 1912, the Bankers Trust Building at Wall and Nassau Streets replaced the Gillender Building. Trowbridge and Livingston designed the 540-foot-high, 41-story building. Its most distinctive feature in the skyline is its pyramidal roof, still a standout even today. Though one of the tallest buildings in the city when completed, by 1932, the Bankers Trust Building was only the 27th tallest structure in the city. (Library of Congress.)

GREELEY SQUARE. This image shows Greeley Square and Broadway at Thirty-third Street. In the foreground is the Wilson Building, built in 1912. Just beyond it is the 27-floor Hotel McAlpin (322 feet high), with 1,440 rooms. It was later converted to residential use. The area was very popular with tourists due to Macy's and other department stores.

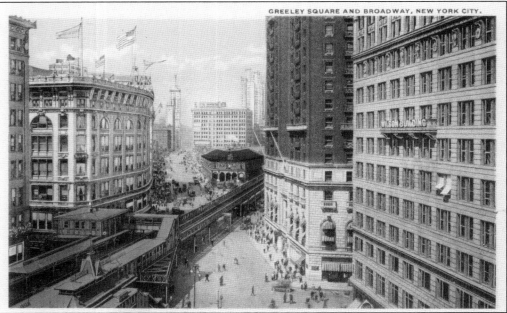

VANDERBILT HOTEL. Constructed in 1912, this hotel had 600 rooms and a prime location on Park Avenue between Thirty-third and Thirty-fourth Streets. At 260 feet high and 20 floors, it was designed by the firm of Warren and Wetmore, who also designed Grand Central Terminal and the addition to the Plaza Hotel. The Vanderbilt is seen here in an E. C. Kropp Company postcard not long after its completion.

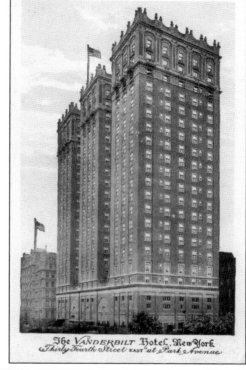

The VANDERBILT Hotel, New York
Thirty-Fourth Street east at Park Avenue

EQUITABLE FIRE. In January 1912, the elegant Equitable Life Assurance Building on Pine Street was destroyed by fire, killing six. It would be replaced by a skyscraper, the current Equitable Building, discussed later in this chapter. (Library of Congress.)

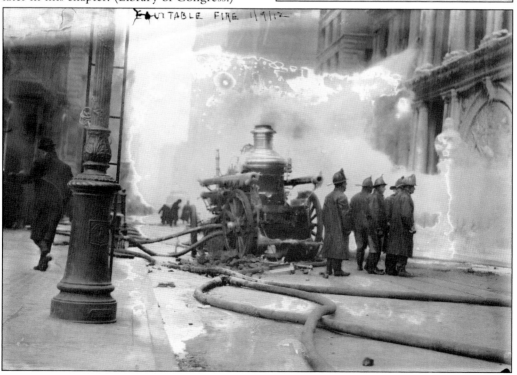

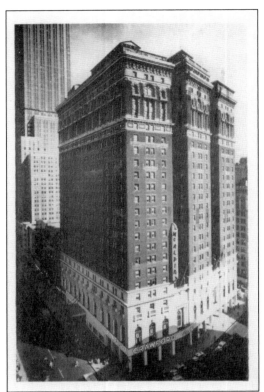

McAlpin Hotel. This 1,440-room hotel was built in 1913 at the busy intersection of Broadway and Thirty-fourth Street. The 27-floor building rises 322 feet high and was designed by F. M. Andrews. It is seen here in a Lumitone Photoprint from the 1940s. The Empire State Building is at left in the background.

Sheraton–Atlantic Hotel. Originally the McAlpin Hotel, the operation of the hotel was taken over by Sheraton in 1954. The hotel was first known as the Sheraton McAlpin, then as the Sheraton-Atlantic. By the 1970s, the building had been converted to residential units.

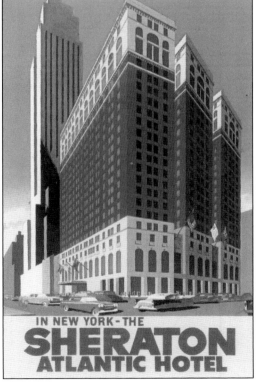

ELEVATED TRAIN. The elevated train used to be a ubiquitous sight around Manhattan. In this image from 1913, the train reaches its highest point above street level—73 feet. In its first several decades, the elevated train was often as high as or higher than the buildings it passed. This changed with the construction of taller and taller buildings during the 1910s and 1920s. There are still elevated trains in New York City, but they are in the outer boroughs.

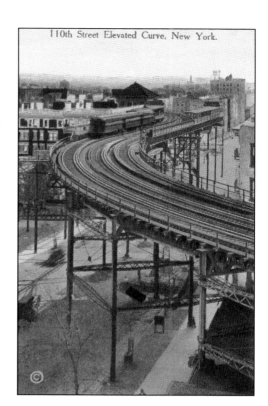

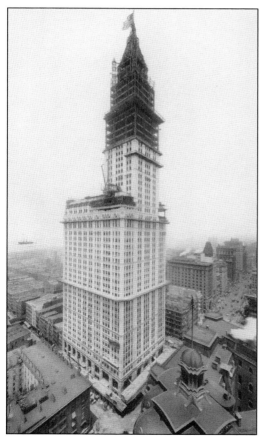

WOOLWORTH BUILDING FLAG RAISING. This Irving Underhill photograph shows the raising of the American flag to the top of what was to become the world's tallest inhabitable building upon the completion of the steel skeleton, or framework, of the Woolworth Building on July 1, 1912. (The Eiffel Tower was taller but is not an inhabitable building.) The 792-foot-high structure was financed by the dime-store millionaire F. W. Woolworth (1852–1919) and completed in 1913.

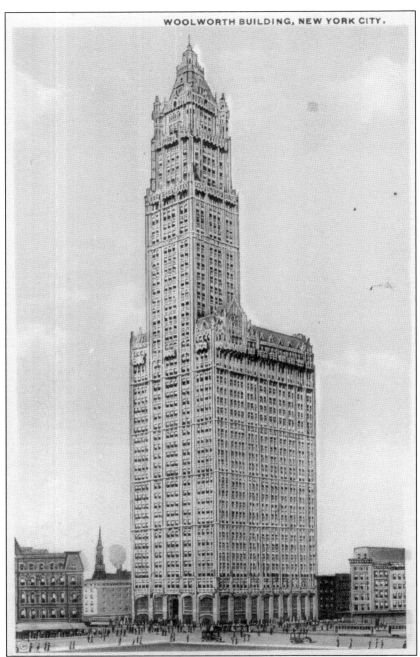

WOOLWORTH BUILDING, NEW YORK CITY.

WOOLWORTH BUILDING. Located at 233 Broadway, the Woolworth Building occupies a plot 152 by 197 feet at Broadway and Barclay Streets. The foundation consists of caissons 19 feet in diameter sunk to bedrock 110 to 130 feet below ground. The Woolworth Building was 401 feet higher than New York City's tallest building just six years earlier, the Park Row Building, and 92 feet higher than the previous record holder, the Metropolitan Life Building. The Woolworth Building was the world's tallest building for 17 years. The Gothic masterpiece, seen in an American Art Company postcard from 1915, cost $13.5 million to construct.

HIGHEST OFFICE BUILDING IN THE WORLD.
When built, the Woolworth Building had 26
Otis elevators, two of them running from the
first to the 51st floor, for a total of 680 feet,
the greatest distance served by any single-
passenger elevator at the time. A shuttle
elevator carried visitors from the 51st floor
to the observation deck on the 54th floor.

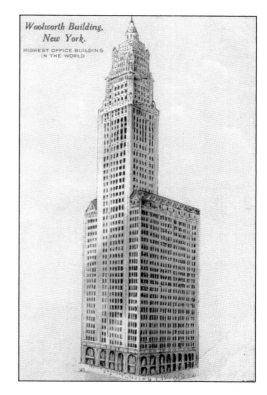

Woolworth Building,
New York.

HIGHEST OFFICE BUILDING
IN THE WORLD

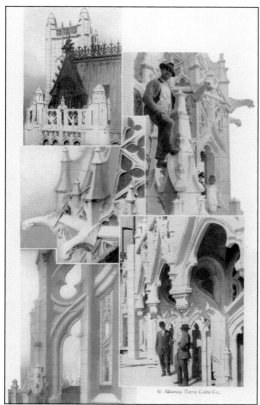

© Atlantic Terra Cotta Co.

WOOLWORTH BUILDING DETAILS.
This photograph montage from a
contemporaneous booklet on the amazing
skyscraper shows some of the terra-cotta
details of the upper floors of the Woolworth
Building, taken at close range. The Gothic
styling of the stonework makes this building
one of the most heavily and beautifully
ornamented skyscrapers in the city.

59

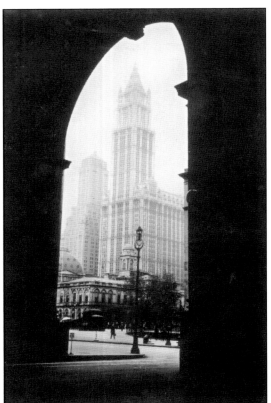

WOOLWORTH BUILDING FRAMED THROUGH ARCHWAY. This photograph of the Woolworth Building framed in an archway of the Municipal Building, taken by amateur photographer Carl Prommersberger around 1928, is similar to a popular postcard view of the time.

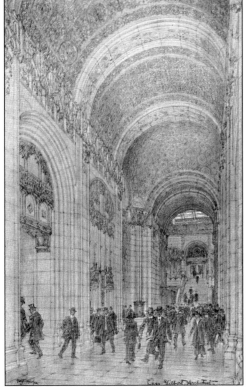

WOOLWORTH BUILDING INTERIOR. This 1912 sketch shows the grand lobby of the Woolworth Building with its soaring arches and ornate decorations. The famous king of the five-and-dime store spared no expense in creating this tower.

WOOLWORTH BUILDING ELEVATORS. This image of the Woolworth Building shows the location and destination of the various elevator banks. Running a combined height of 2 miles, its elevator shafts easily beat the three-quarter mile of elevator shafts in the Singer Building and 1.5 miles of elevator shafts in the Met Life Building.

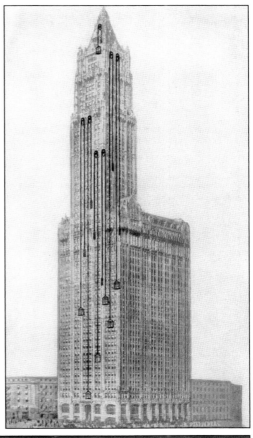

WOOLWORTH BUILDING AT NIGHT. This is a dramatic Success Postal Card view showing the Woolworth Building at night, postmarked 1918. The pinnacle of the Singer Building is visible farther downtown. The glittering night skyline of Manhattan was a sight to behold for visitors from small towns where the night sky was completely dark. When constructed, the Woolworth Building had 80,000 lights compared to just 14,500 for the Singer Building.

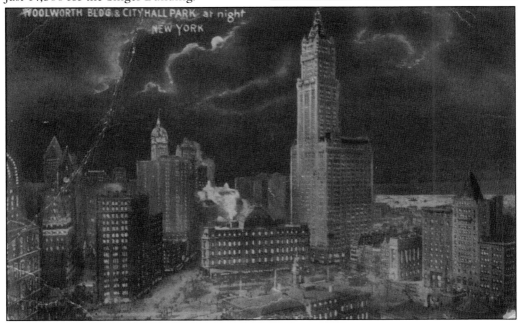

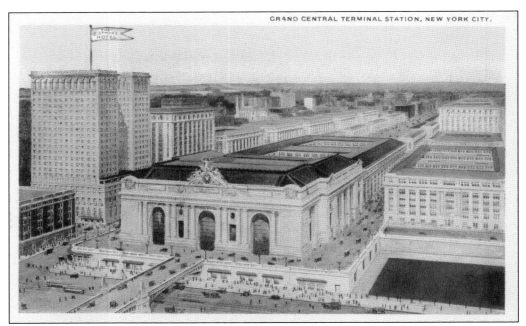

BILTMORE HOTEL AND GRAND CENTRAL. The 30-story Biltmore Hotel (321 feet high), across from Grand Central Terminal at Forty-third to Forty-fourth Streets between Madison Avenue and Vanderbilt Avenue, was built in 1914. The famous architectural firm of Warren and Wetmore, which also designed neighboring Grand Central Terminal, designed the 1,000-room hotel. Sir Arthur Conan Doyle was once a guest at the hotel. As evident in this American Art Publishing Company image above and the anonymous image below, the same base photograph was often used by different postcard companies with only slight variations. The primary difference in these two images is the Biltmore Hotel flag on the American Art image. The color tones are also different between the two, and the American Art image features a clear sky while the anonymous image shows clouds.

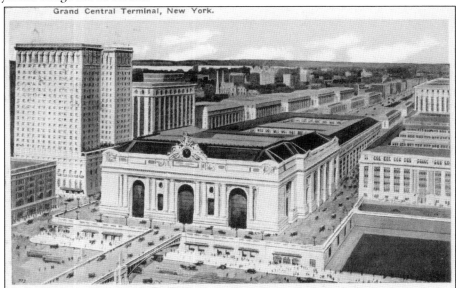

Grand Central Terminal, New York.

BILTMORE HOTEL. Image quality in postcards varied greatly. Photo postcards tend to be the sharpest, and linens tend to be less crisp. This rather poorly painted image of the Biltmore Hotel appears on an undated American Press postcard; in this case, the quality has nothing to do with the type of card. The reverse of the card proclaims, "Meet me under the clock at the Biltmore—World's best known meeting place."

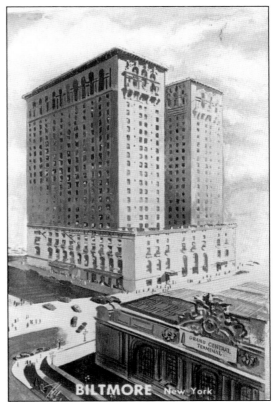

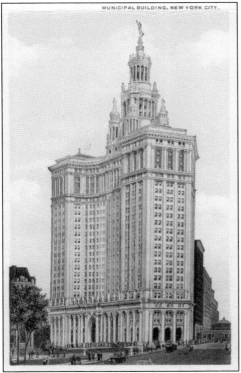

MUNICIPAL BUILDING, ARTIST'S CONCEPTION. The Municipal Building is a New York City government building at 1 Centre Street, opposite City Hall Park and just north of the Manhattan entrance to the Brooklyn Bridge. Rising 40 stories (580 feet), the impressive 600,000-square-foot limestone building was completed in 1915 after several years of construction. Of note, this postcard must have been printed before the building's completion because the finials depicted atop the four small towers surrounding the main tower are incorrect. The actual towers were topped by pointed roofs and not statues; in fact, these details were among the last components of the building to be completed.

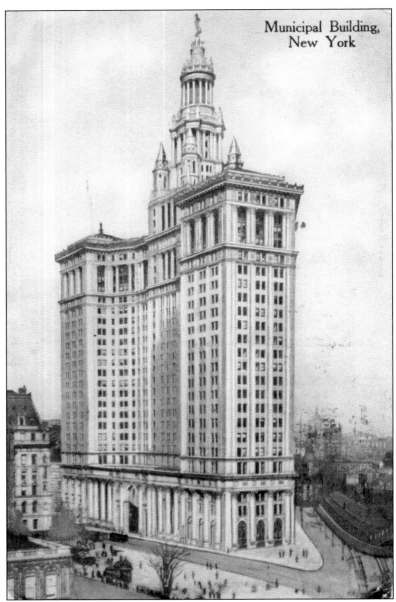

Municipal Building,
New York

MUNICIPAL BUILDING, SIDE ANGLE. This close-up view of the Municipal Building shows its dominance of the skyline in the New York City Hall area. The architectural magnificence and grand scale of the structure were unheard of for a municipal building. The classically styled structure was designed by the famous firm of McKim, Mead, and White and contains a subway station at its lowest level. The foundations for the Municipal Building were completed at a cost of $1.3 million. The foundations for the main columns of the structure consist of 106 caissons, of which 68, comprising those under the tower and the southerly portion of the building, extend to bedrock at a depth between 75 and 112 feet. The remaining caissons, under the northerly portion of the building, rest on sand about 40 feet under the surface. There are 65 rectangular caissons and 41 circular caissons. The building is seen here in a *c.* 1915 Success Postal Card Company image.

MUNICIPAL BUILDING. Seen in this *c.* 1918 Century Post Card and Novelty Company image, the Municipal Building is one of the most impressive city government buildings ever constructed in the United States and, at the time of its construction, was the largest building of its kind in the world. Atop the building is perched a 30-foot-high statue of *Miss Civic Pride*, designed by Adolph Weinman. The total cost of the 580-foot-high building was $13 million. The monumental building was rehabilitated in 1992.

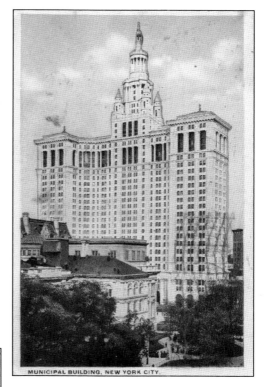

MUNICIPAL BUILDING, NEW YORK CITY.

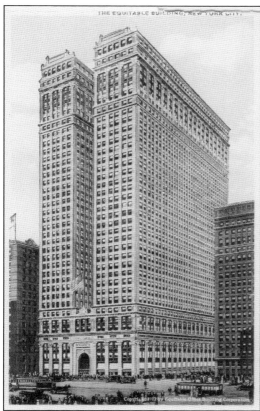

EQUITABLE BUILDING. As noted earlier, the original Equitable Building was destroyed by fire. Its grand replacement, seen here in a 1913 rendering before its actual completion in 1915, cost about $29 million to construct, and in sheer size was the largest office structure in the world when built.

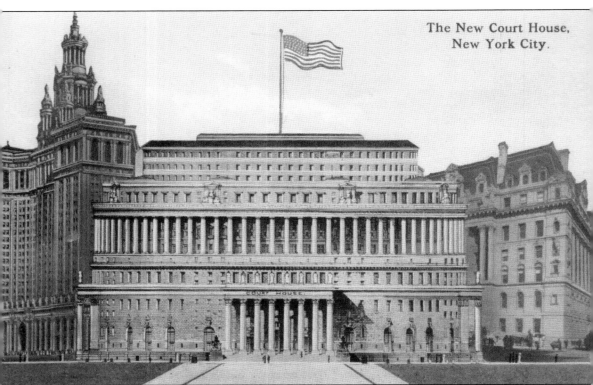

NEW COURTHOUSE. This is a *c.* 1915 American Art postcard depicting a rendering of what the proposed new courthouse at Worth, Lafayette, and Centre Streets was to look like. Designed by Guy Lowell, who beat out 21 other architects to win the design commission, the original plan was for a colossal circular building with a diameter of 400 feet and a height of 200 feet, occupying four city blocks. However, the courthouse commission rejected this circular building design. A modified design was accepted, and the scaled-back courthouse building (at a reduced height) finally opened in 1927, the year that Lowell died. The building at left in this postcard is the Municipal Building.

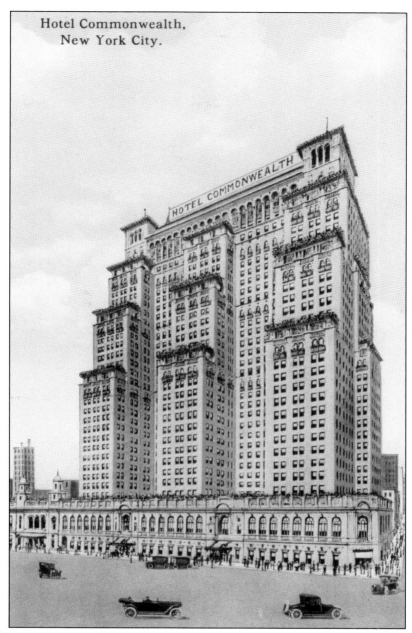

Hotel Commonwealth,
New York City.

HOTEL COMMONWEALTH. This *c.* 1917 postcard shows a rendering of the proposed new Hotel Commonwealth, according to the reverse of the card, the "first important building" to be designed in accordance with the new setback law that mandated tall buildings could not rise straight up but had to have setbacks to "conserve light, air, and sunshine for the general public." The 2,500-room hotel was to stand at Times Square at a height of 28 stories and 400 feet, featuring flowering shrubs on terraced setbacks, "rivalled only by the ancient Hanging Gardens of Babylon." Due to funding problems, the hotel was never actually built. It was not uncommon for early-20th-century postcards to be issued before a building was completed, and sometimes even before any ground was broken.

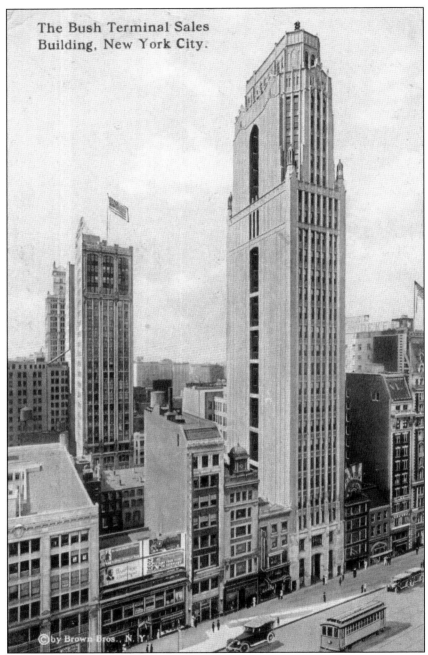

The Bush Terminal Sales Building, New York City.

©by Brown Bros., N.Y.

BUSH TERMINAL SALES BUILDING. Completed in 1918 as World War I drew to a close, the Bush Terminal Sales Building on West Forty-second Street was built on a narrow strip of land under 60 feet in width. With 30 floors, the building was 430 feet high with 130,000 square feet of office space and was home to many American and foreign manufacturers and importers. The Buyers Club of New York leased space there; it provided interpreters and translators to its members. Merchants could look over product samples and catalogues from many different manufacturers.

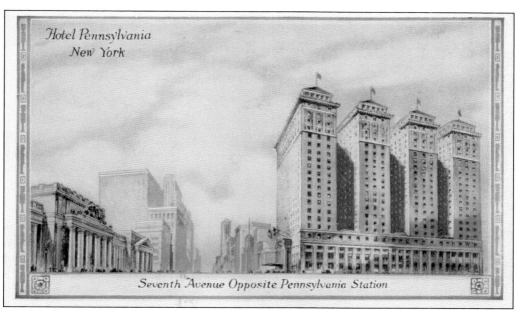

HOTEL PENNSYLVANIA. At the time of its completion in 1919, the Hotel Pennsylvania was one of the 12 largest hotels in the world. Located on Seventh Avenue directly across from Pennsylvania Station, it was designed by the famous firm of McKim, Mead, and White. The 30-floor hotel rises 310 feet high. Upon completion, it had 2,200 guest rooms. The Hotel Statler Company originally operated it. This hotel's phone number was the subject of a famous song by bandleader Glenn Miller called "Pennsylvania 6-5000," thus making it one of the best-known hotels in the world.

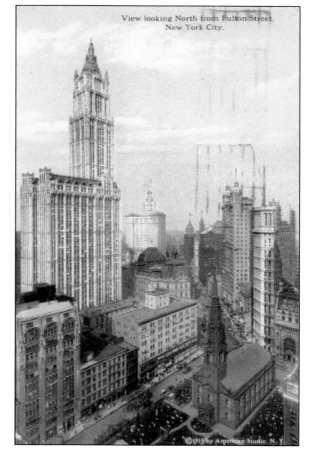

View looking North from Fulton Street, New York City.

LOOKING NORTH FROM FULTON STREET. The towering Woolworth Building is visible at left. In the distance to its immediate right is the Municipal Building, and on the right is the Park Row Building. St. Paul's Chapel is in the foreground in this 1919 view.

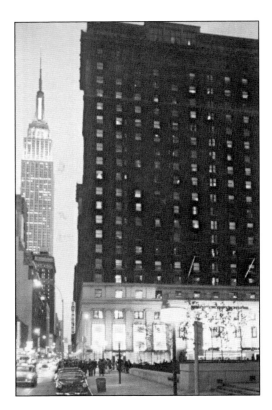

STATLER HILTON. This 1976 Dexter postcard shows the Hotel Pennsylvania when it was known as the Statler Hilton. The Empire State Building is just a few blocks to the north.

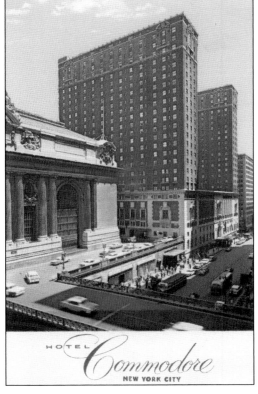

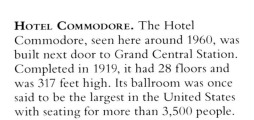

HOTEL COMMODORE. The Hotel Commodore, seen here around 1960, was built next door to Grand Central Station. Completed in 1919, it had 28 floors and was 317 feet high. Its ballroom was once said to be the largest in the United States with seating for more than 3,500 people.

MUNICIPAL AND WOOLWORTH BUILDINGS.
This *c.* 1920 postcard shows a view from
the North River (Hudson River). The
description on the reverse reads: "These
two buildings are the largest of their
kind in the world. . . . They are situated
in the heart of the business section,
overlooking the North River and its
tremendous traffic. The largest ocean-
going steamers enter this river, carrying
merchandise from all parts of the world."

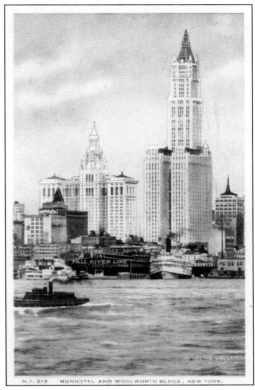

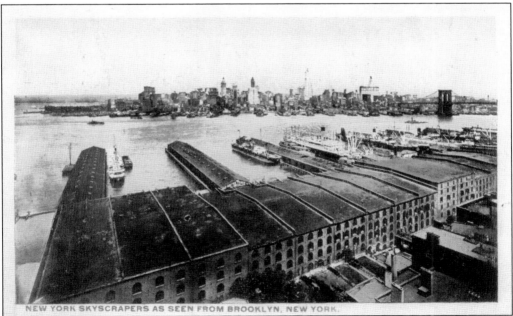

SKYLINE FROM BROOKLYN. This Union News Company image postmarked in 1920 shows the
lower Manhattan skyline from the wharves of Brooklyn. The four tallest buildings in this image
are, from left to right, the Bankers Trust, Singer, Woolworth, and Municipal Buildings.

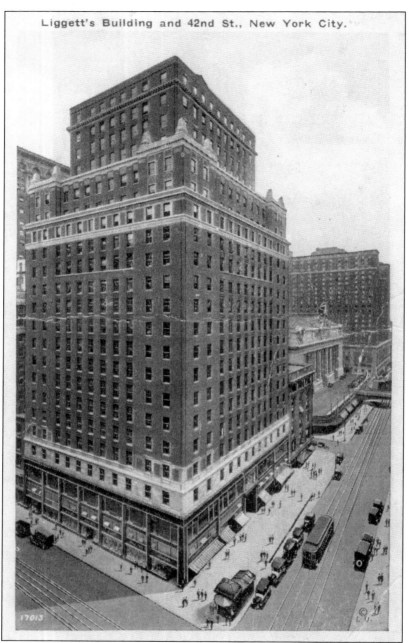

Liggett's Building and 42nd St., New York City.

LIGGETT BUILDING. The Liggett Building was completed in 1921 at Forty-second Street and Madison Avenue, having taken only a year to build. The architect was Carrere-Hastings and Shreve. At 23 stories, the building rose 313 feet high on property formerly owned by the Holy Trinity Church. The office worker capacity was 4,000. Liggett was a famous drugstore chain in the 1920s. The owner of the Liggett chain also owned the Rexall brand. The tenants included the Texas Gulf Sulphur Company, the R. W. Benson Company, the Central Foundry Company, and the American Flexible Bolt Company. This 1920s postcard was printed by Haberman's using an Irving Underhill image.

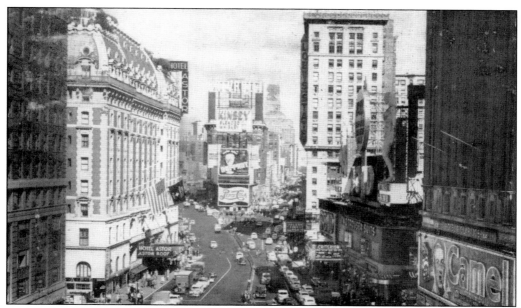

LOEWS STATE THEATER BUILDING.
Designed by Thomas W. Lamb
and completed in 1921, the Loews
State (right center) was located at
Forty-fifth Street and Broadway.
The 17-story building has since been
demolished. The Astor Hotel is at
left in this Lumitone Photoprint
card from around the early 1950s.

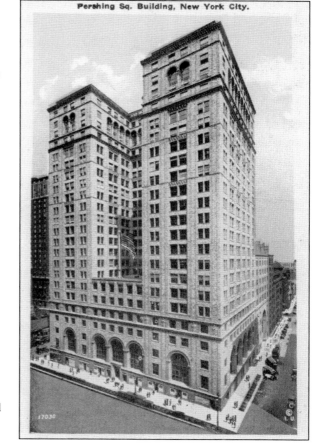

PERSHING SQUARE BUILDING.
Located at 100 East Forty-second
Street on Park Avenue, the Pershing
Square Building was completed
in 1923. With 27 stories and over
440,000 square feet of space, it could
hold 5,000 office workers and is 293
feet high. It was created by Sloan and
Robertson, who also designed the
more well-known Chanin Building.

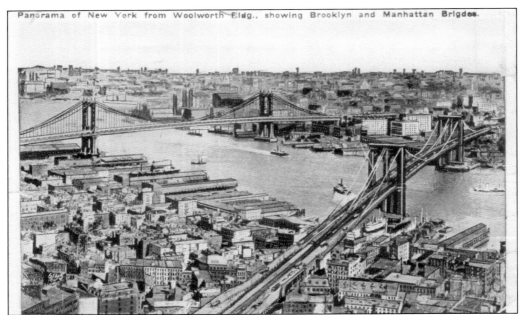

PANORAMA FROM WOOLWORTH BUILDING. This *c.* 1923 view shows the Brooklyn (foreground) and Manhattan (background) Bridges spanning the East River. The Manhattan Bridge was completed in 1909. With a river span of 1,470 feet and a total length of 6,855 feet, the towers are 322 feet above water level. The cost of completion was $24 million. Note the misspelling of the word "Bridges" on this postcard.

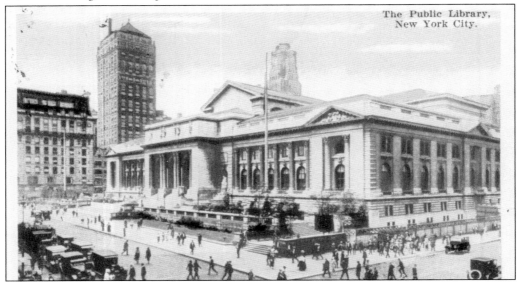

The Public Library, New York City.

NEW YORK PUBLIC LIBRARY AND 10 WEST FORTIETH STREET. One of the earliest skyscrapers in the vicinity of Forty-second Street was 10 West Fortieth Street. The 22-story, 265-foot-high building was constructed in 1915, designed by Starrett and Van Vleck. This 1920s Manhattan Card Publishing Company image also shows the top of the American Radiator Building, a highly stylized 337-foot tower completed in 1924 and designed by Raymond Hood, who would later go on to design the Chrysler Building.

THE ROOSEVELT HOTEL. Located between Madison Avenue and Vanderbilt Avenue at Forty-fifth and Forty-sixth Streets, the hotel was built near Grand Central Terminal and was designed by George M. Post and Sons. Completed in 1924, the 24-floor, 253-foot-high hotel had 1,100 rooms. Among other attractions, it featured a "Teddy Bear Cave" for children. Seen in an early 1930s Lumitone Photo-Print postcard, the hotel is still open today.

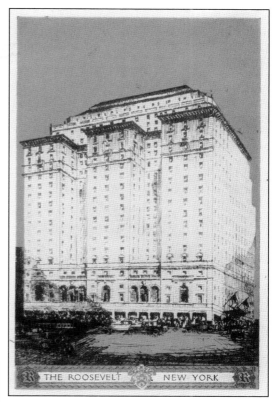

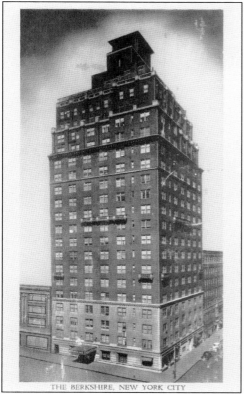

THE BERKSHIRE. The 21-story, 350-room Berkshire was built in 1926. Seen in a *c.* 1940s East and West Postcard Company image, it was located at Madison Avenue and Fifty-second Street, not far from Radio City Music Hall.

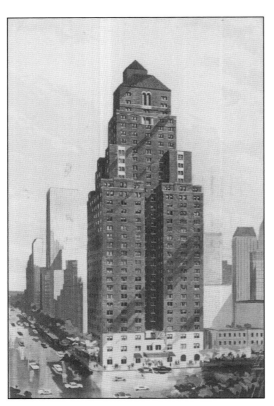

WARWICK HOTEL. Seen in this 1976-postmarked United Color postcard, the Warwick Hotel (later the Loews Warwick) was built in 1926. At 370 feet high, the red-roofed hotel had 36 stories and 512 guest rooms. Built at the corner of Sixth Avenue and Fifty-fourth Street, the structure's designer was the George B. Post Company.

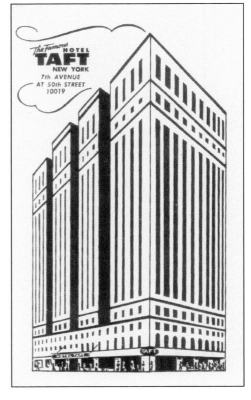

HOTEL TAFT. The Hotel Taft (formerly the Manger) was located at Seventh Avenue and Fiftieth Street, near Radio City Music Hall. Seen in this undated postcard, it was built in 1927 and featured 2,000 rooms. The 222-foot-high building had 21 floors. Though hotels were built throughout Manhattan, the area between Fifth and Eighth Avenues from Thirtieth Street to Fiftieth Street saw the highest concentration of them due to the area's proximity to Penn Station, Times Square, and Rockefeller Center.

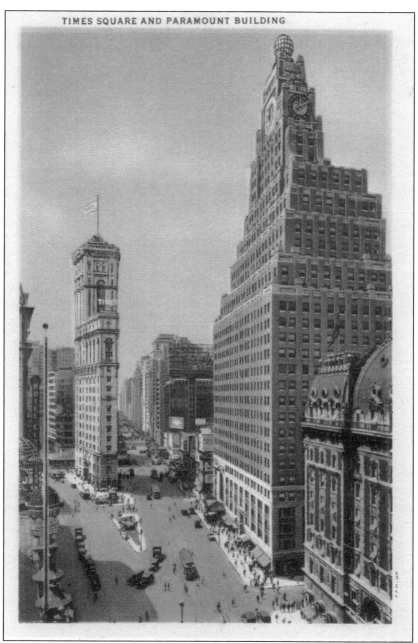

PARAMOUNT BUILDING. Located on Broadway at Times Square between Forty-third and Forty-fourth Streets, the Paramount was completed in 1927 for the Paramount Pictures Corporation. It is located on the site of the old Putnam Building (demolished in 1926), home of Shanley Café. The 455-foot-high, 36-floor building (300,000 square feet of space) has a distinctive appearance due to its many setbacks and its large clock near the top. At one point, it had an observation tower accessible for the price of 25¢. The architects were C. W. and G. L. Rapp. The building is still a standout even today, with its art deco styling a marked contrast to the modern glitz of Times Square.

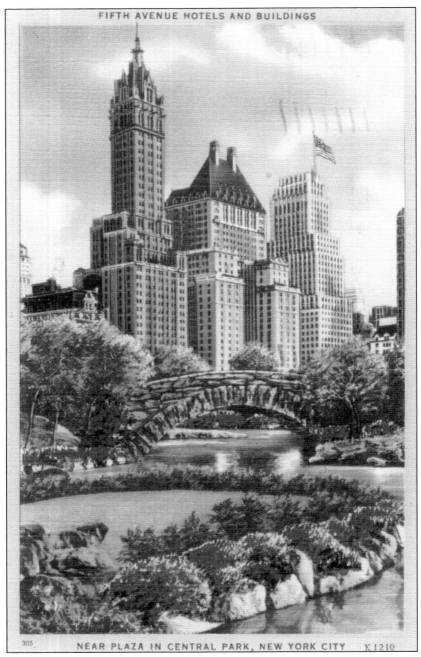

305 NEAR PLAZA IN CENTRAL PARK, NEW YORK CITY K 1210

SHERRY-NETHERLAND AND SAVOY-PLAZA HOTELS. This 1950s view was taken from Central Park looking toward Fifth Avenue. The Sherry-Netherland Hotel is 573 feet high (topped with a Gothic minaret) with 40 floors and 525 guest rooms. Completed in 1927, it is located at Fifth Avenue and Fifty-ninth Street facing Central Park and is still open today. Next to the hotel in this image is the 419-foot-high, 37-floor, 1000-room Savoy-Plaza Hotel (not to be confused with the nearby famous Plaza Hotel), also completed in 1927 and designed by McKim, Mead, and White. The Savoy-Plaza was demolished in 1964.

HOTEL MANHATTAN. Built in 1928, this hotel later became known as the Milford Plaza. Located at Eighth Avenue between Forty-fourth and Forty-fifth Streets, it had 1,400 rooms and 28 floors. The Milford Plaza became famous for its 1980s commercials featuring a jingle sung to the tune of the popular old song "Lullaby of Broadway." This image was published by Hannau Color Productions.

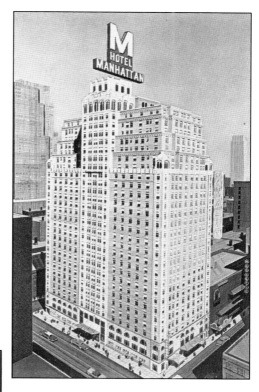

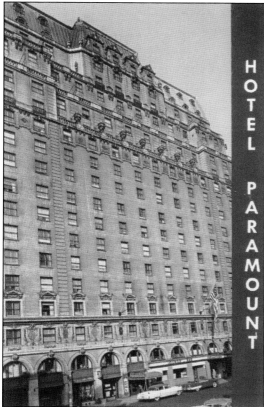

HOTEL PARAMOUNT. Seen in this 1950s postcard, the Hotel Paramount was built at Forty-sixth Street west of Broadway. Constructed in 1928, it had 700 guest rooms on 22 floors and rose 252 feet high. The architect was Thomas W. Lamb, and the building's construction cost was $4.6 million.

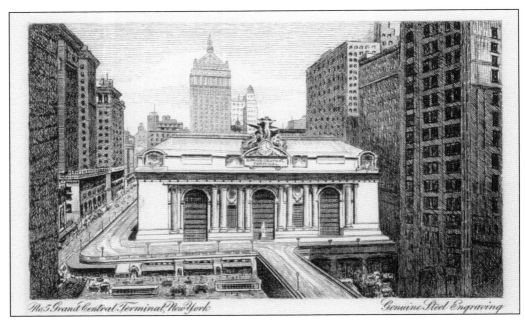

GRAND CENTRAL TERMINAL AND THE NEW YORK CENTRAL BUILDING. Located at 230 Park Avenue, from Forty-fifth to Forty-sixth Streets, the New York Central Building (directly behind the terminal in these images) was completed in 1928. The 40-floor building rises 566 feet high and was designed by Warren and Wetmore. It was constructed on stilts over two levels of railroad tracks. The view of this building from the south was obscured by the construction of the Pan Am Building in 1963. The New York Central Building is shown here in an undated I. Scheff Engraving Company view (above) and an undated Albertype Duotone postcard (below).

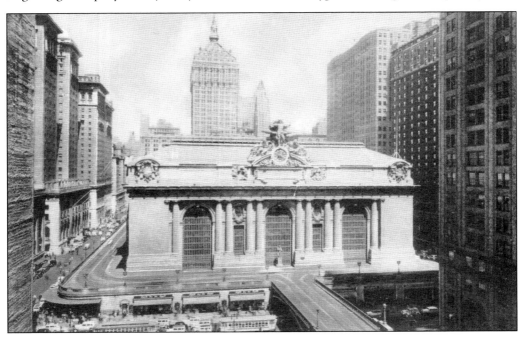

HOTEL VICTORIA. Built in 1928 and designed by Schwartz and Gross, the hotel was located at Seventh Avenue and Fifty-first Street (781 Seventh Avenue). It had 25 floors and was 270 feet high with 1,000 guest rooms. It was located next to the Hotel Taft, which was completed in 1927. Into the 1950s, it was still common for hotels to advertise that they were "completely air-conditioned" and that every room had a private bath and television, things that are taken for granted today.

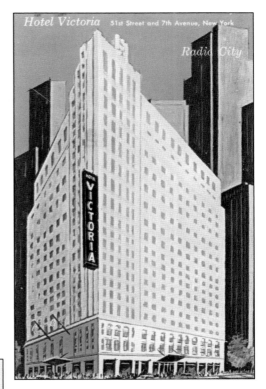

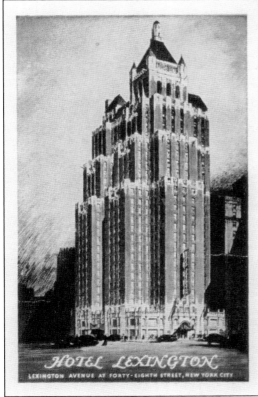

HOTEL LEXINGTON, 115 LEXINGTON AVENUE. The elegant Hotel Lexington, at Lexington Avenue and Forty-eighth Street, was designed by Schultze and Weaver, designers of the Waldorf-Astoria, and completed in 1929. At 336 feet high, it has 30 floors. Originally, it had 800 guest rooms. The hotel is now a Radisson and has 712 rooms. It is seen here in a Hilite Process postcard.

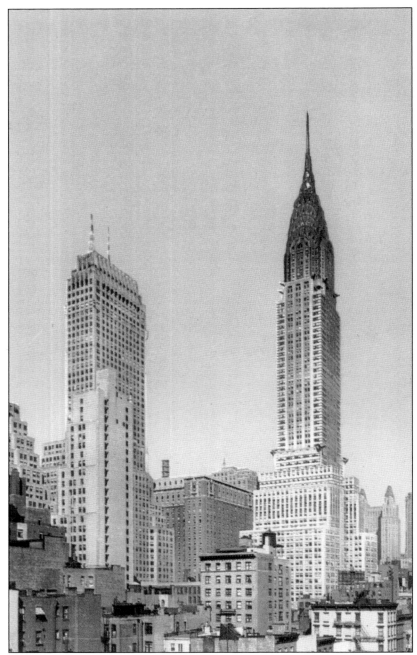

CHANIN BUILDING AND CHRYSLER BUILDING. This is a Plastichrome image published by the Manhattan Post Card Publishing Company. The 680-foot-high, 56-floor Chanin Building, at 122 East Forty-second Street, was designed by Sloan and Robertson and completed in 1929 at a cost of $14 million. Commissioned by Irwin Chanin, head of the Chanin development organization, it was the third tallest building in the world when completed. Known for its graceful art deco symmetry, the building has long dominated the Times Square skyline. Like many Manhattan skyscrapers, it has an observation deck, but the deck is now closed to the public.

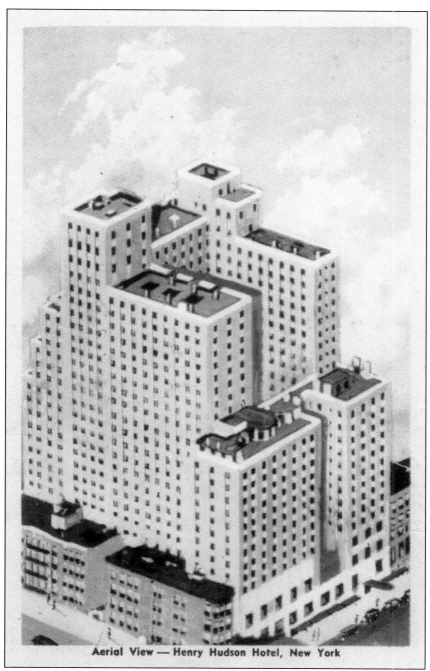

Aerial View — Henry Hudson Hotel, New York

HENRY HUDSON HOTEL. This 1940s Dexter Colorcraft postcard shows an aerial view of the hotel, located at Fifty-seventh Street just west of Broadway. The 27-story art deco structure was completed in 1929. It cost $7 million to build and contained six lounges, five sun decks, a 60-foot pool, three restaurants, roof gardens, and 1,200 guest rooms. Designed by Benjamin Wistar Morris, the architect of the landmark Bank of New York and Trust Company Building on Wall Street, the structure was formerly home to the clubhouse of the American Women's Association.

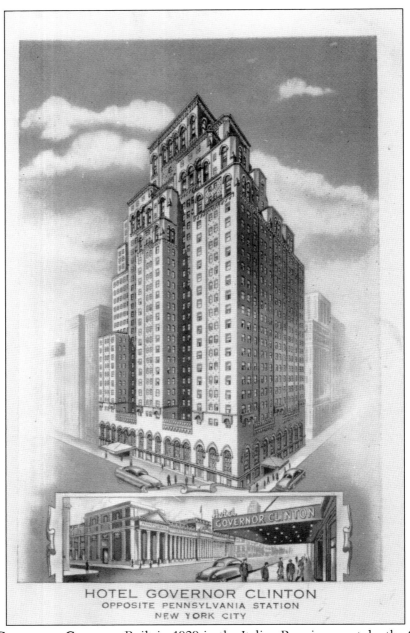

HOTEL GOVERNOR CLINTON
OPPOSITE PENNSYLVANIA STATION
NEW YORK CITY

HOTEL GOVERNOR CLINTON. Built in 1929 in the Italian Renaissance style, the Governor Clinton had 32 floors and was 378 feet high. Present at the opening banquet were Gov. Franklin Roosevelt and former governor Al Smith along with Mayor Jimmy Walker. Located at the corner of Thirty-first Street and Seventh Avenue (across from Pennsylvania Station), the Governor Clinton was named after former governor and vice president George Clinton and was designed by Murgatroyd and Ogden. It was later known as the Southgate Tower and is currently known as the Affinia Manhattan (with 526 suite-sized rooms). The back of this postcard proclaimed that the rooms featured Servidors, special compartments in which to leave clothes that needed pressing. Hotel staff could access the compartments from the hallway and collect the clothes.

Four

1930–1954

The 1930s were the height of the art deco style in New York skyscrapers. Whether the ornate opulence of the Chrysler Building or the understated beauty of the symmetrical Empire State Building, an amazing number of skyscrapers were completed just as the Great Depression was beginning. The 20 tallest buildings in New York as of 1949 had all been built before 1932, and 13 of them were completed between the years 1930 and 1932, including the Chrysler Building, Empire State Building, American International Building, 40 Wall Street Tower, the Lincoln Building, the Irving Trust Building, and the RCA Building. Few tall buildings were begun during the height of the Depression. World War II brought the country out of the Depression, but it also meant that precious resources such as steel were needed for munitions, and so major new office projects were virtually unheard of again until 1946.

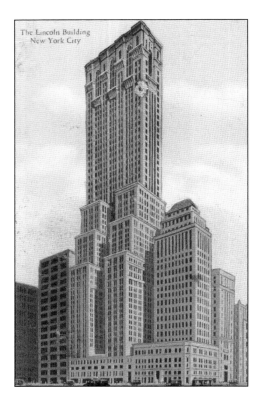

The Lincoln Building
New York City

LINCOLN BUILDING. The neo-Gothic Lincoln Building, located at 60 East Forty-second Street (and Madison Avenue, across from Grand Central Terminal), is 55 stories and 680 feet high. Designed by James Carpenter and completed in 1930, it has space for 12,000 workers and was one of the 10 largest office buildings in the world at the time of its construction. This postcard was published in the year of the Lincoln Building's completion.

RIVERSIDE CHURCH. Seen in a *c.* 1959 view, the Riverside Church (Baptist) was built in the French Gothic style. Located at Riverside Drive and 123rd Street near Grant's Tomb and Columbia University, the church is 392 feet high, making it one of the tallest churches in the world, and seats 2,500 people. Construction of the church was funded by the wealthy John D. Rockefeller.

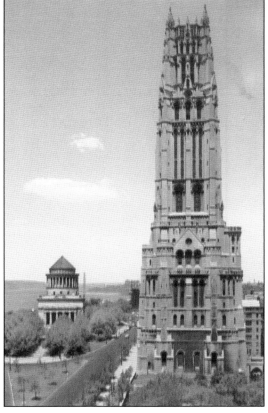

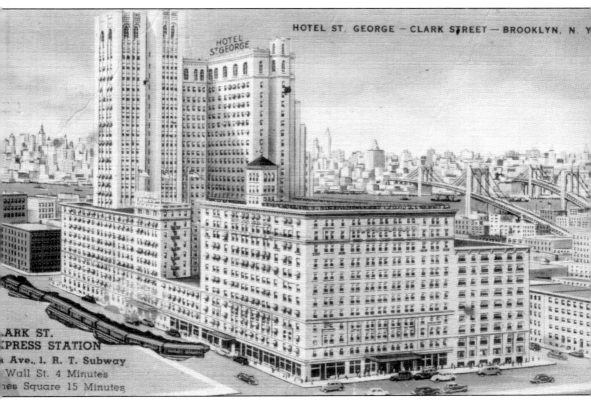

HOTEL ST. GEORGE. Located at 51 Clark Street in Brooklyn, the tower of the Hotel St. George was completed in 1930, with other portions having been built earlier. It featured 2,600 rooms and was at one time the largest hotel in the eastern United States. The tower rises 400 feet and contains 33 floors. When built, there were 21 elevators and a huge indoor swimming pool. Though the building was considered tall for a structure in one of the outer boroughs, it was dwarfed by the Williamsburgh Savings Bank Building (also in Brooklyn), completed in 1920, with a height of 512 feet. Because of its location at a subway station, Wall Street was reachable in four minutes under ideal conditions. This is a Colourpicture linen postcard from the late 1940s.

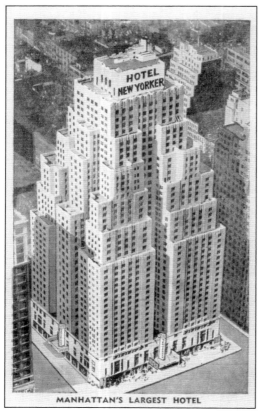

MANHATTAN'S LARGEST HOTEL

HOTEL NEW YORKER. Located on Eighth Avenue between Thirty-fourth and Thirty-fifth Streets, the New Yorker is one of the most famous hotels in the city. At the time of its construction in 1930, it was billed as Manhattan's largest hotel. Designed by Sugarman and Berger, it was built at a staggering cost of $20 million. The 2,500-room, 43-story art deco hotel, standing 525 feet high, was built with 23 elevators. It is still in operation today, now part of the Ramada chain of hotels. At left is a 1940s linen postcard by the E. C. Kropp Company and below is a chrome by the Chester Litho Corporation from the 1950s, which proclaims it to be "New York's Largest—Most Fabulous Skyscraper Hotel."

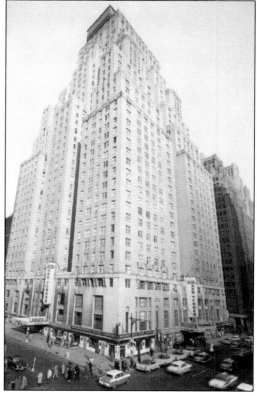

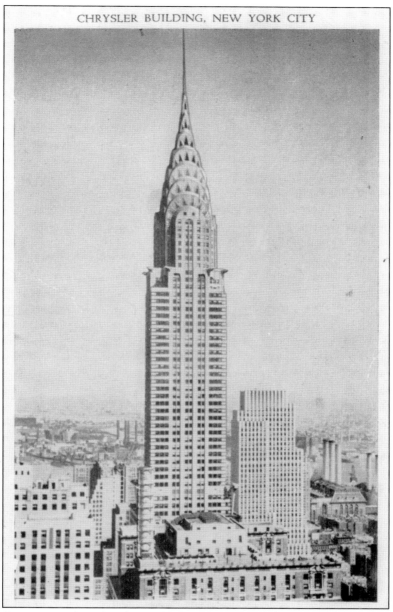

CHRYSLER BUILDING. The Chrysler Building, located between Forty-second and Forty-third Streets at 405 Lexington Avenue, is one of the best known of New York City's skyscrapers. It was named after its developer, the automobile titan Walter P. Chrysler, and this was reflected in its automotive-inspired ornamental details. Though height wise it was relegated to the Empire State Building's shadow only months after its construction in 1930, the highly stylized art deco steel exterior, designed by William Van Alen, sets it apart from all other New York skyscrapers of the era. Nearly 21,000 tons of steel and nearly four million bricks were used in the making of this 1,046-foot-high, 77-story giant with distinctive triangular windows in its stepped tower. It is seen here in an undated East and West Publishing Company image. The stunning exterior is matched by an equally stunning stylized art deco interior.

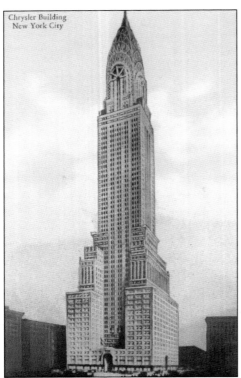

Chrysler Building
New York City

CHRYSLER BUILDING FROM STREET LEVEL. This postcard shows the entire building seen from street level shortly after its completion. The 77-story building rises to a height of 1,046 feet with capacity for 11,000 office workers.

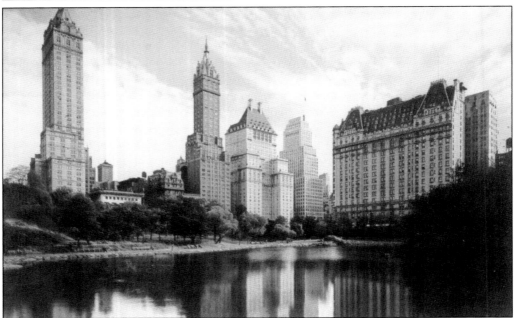

HOTEL PIERRE. Here is another view from Central Park. Besides the Sherry-Netherland and Savoy-Plaza (center), this card also shows the Hotel Pierre (left) located at Fifth Avenue and Sixty-first Street. The 503-foot-high building has 44 floors and 700 guest rooms. The building was completed in 1930.

HOTEL DIXIE. Designed by the noted hotel architect Emery Roth, the Hotel Dixie opened in 1930 on Forty-third Street just west of Broadway. It had 25 floors at a height of 267 feet and 650 guest rooms. It is currently known as the Hotel Carter.

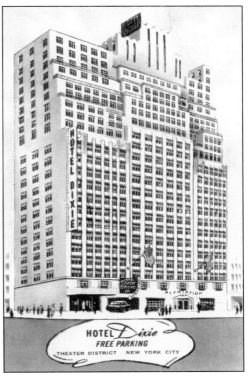

500 FIFTH AVENUE. The 58-story office building was constructed at the corner of Fifth Avenue and Forty-second Street, opposite the New York Public Library and Bryant Park. According to the postcard text, it "occupies the most advantageous corner of the best known street intersection in the world." Designed by Shreve Lamb and Harmon, the 473,000-square-foot building rises to a height of 701 feet and was completed in 1930–1931, the approximate date of this postcard.

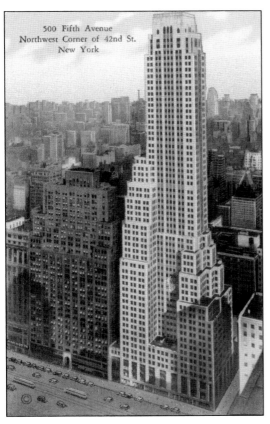

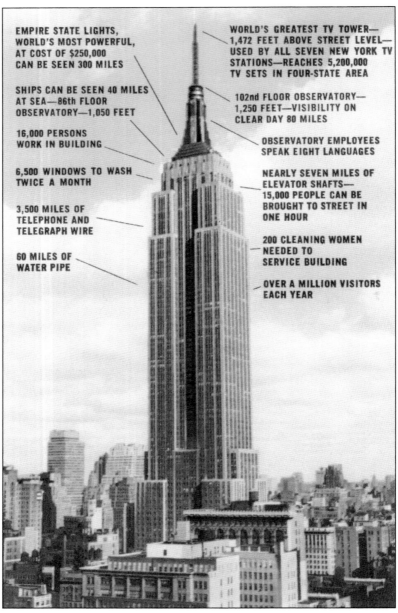

EMPIRE STATE LIGHTS,
WORLD'S MOST POWERFUL,
AT COST OF $250,000
CAN BE SEEN 300 MILES

SHIPS CAN BE SEEN 40 MILES
AT SEA—86th FLOOR
OBSERVATORY—1,050 FEET

16,000 PERSONS
WORK IN BUILDING

6,500 WINDOWS TO WASH
TWICE A MONTH

3,500 MILES OF
TELEPHONE AND
TELEGRAPH WIRE

60 MILES OF
WATER PIPE

WORLD'S GREATEST TV TOWER—
1,472 FEET ABOVE STREET LEVEL—
USED BY ALL SEVEN NEW YORK TV
STATIONS—REACHES 5,200,000
TV SETS IN FOUR-STATE AREA

102nd FLOOR OBSERVATORY—
1,250 FEET—VISIBILITY ON
CLEAR DAY 80 MILES

OBSERVATORY EMPLOYEES
SPEAK EIGHT LANGUAGES

NEARLY SEVEN MILES OF
ELEVATOR SHAFTS—
15,000 PEOPLE CAN BE
BROUGHT TO STREET IN
ONE HOUR

200 CLEANING WOMEN
NEEDED TO
SERVICE BUILDING

OVER A MILLION VISITORS
EACH YEAR

EMPIRE STATE BUILDING. Construction of the Empire State Building began in March 1930 on the former site of the Waldorf-Astoria Hotel. Designed by Shreve, Lamb, and Harmon Associates, the Empire State required 60,000 tons of steel. Development of the skyscraper was led by John Jakob Raskob, the founder of General Motors. This 1960s postcard of the Empire State Building shows some of the pertinent facts about the skyscraper, mentioning its 6,500 windows, 60 miles of water pipe, and capacity to house 16,000 workers. The Empire State Building was officially opened on May 1, 1931, eclipsing the Chrysler Building as the world's tallest. This image also shows the television tower (added in 1951 to the 1,224-foot-high building), which brings the total height of the Empire State Building to a soaring 1,472 feet. The Eighty-sixth floor observation deck receives over three million visitors every year.

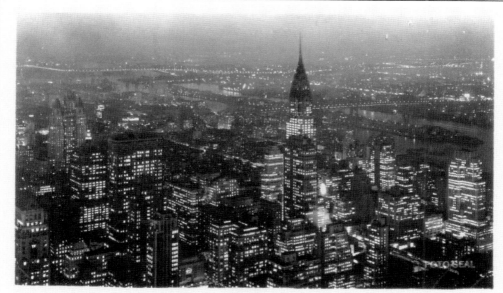

North-East View from the Empire State Bldg., New York City, at Night. 22

VIEW FROM EMPIRE STATE BUILDING AT NIGHT. Since it opened, visitors have been marveling at the amazing views from the observation decks on the 86th and 102nd floors. As the New York skyline changed over the years, so has the view, seen here in this undated Foto Seal photo postcard. One thing has remained constant—the dominance of the Empire State Building over midtown. The top floors are lit in a variety of colors depending on the season or holiday.

McGRAW HILL BUILDING. Located on Forty-second Street between Eighth and Ninth Avenues, the original McGraw Hill Building (330 West Forty-second Street) was designed by Raymond Hood in the "International Style" and was completed in 1931. It was the first skyscraper on Forty-second Street to be built west of Eighth Avenue. The building's height is 488 feet, with 36 floors and 580,000 square feet of space. Unlike many of its contemporaries, it is unornamented, although its exterior is clad in distinctive blue-green terra-cotta tiles. Its windows are also prominently featured, not relatively hidden within a brick facade.

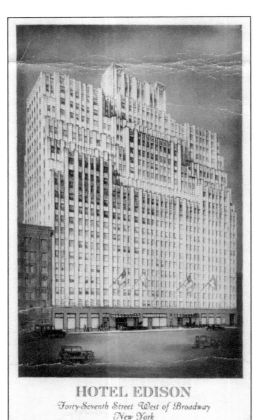

HOTEL EDISON
Forty-Seventh Street West of Broadway
New York

HOTEL EDISON. The massive Hotel Edison was completed in 1931. Thomas Edison himself threw a switch by remote control to turn on the lights when the hotel opened. The building rose to a height of 287 feet, with 26 floors, 1,000 guest rooms, and banquet accommodations for 1,500. The architect was Herbert J. Knapp. It boasted three restaurants, and in an attempt to mimic a more famous hotel's phone number (Pennsylvania 6-5000), it could be reached at Circle 6-5000. Seen in a Lumitone Photoprint from the 1930s and a Chester Litho postcard from the 1940s, the hotel is still in operation today. It is located between Forty-sixth and Forty-seventh Streets west of Broadway. In the later image, the building appears to be taller and narrower than in the earlier image, proving that postcards did not always depict reality.

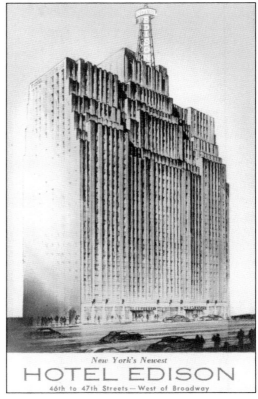

New York's Newest
HOTEL EDISON
46th to 47th Streets — West of Broadway

GEORGE WASHINGTON BRIDGE. This 1950s Plastichrome postcard shows the view from the top of the George Washington Bridge, which spans over the Hudson River and connects Bergen County, New Jersey, with Manhattan. The bridge opened in 1932. Its towers soar to a height of 604 feet above the water.

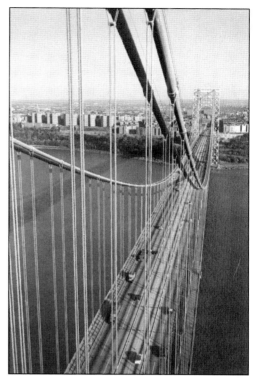

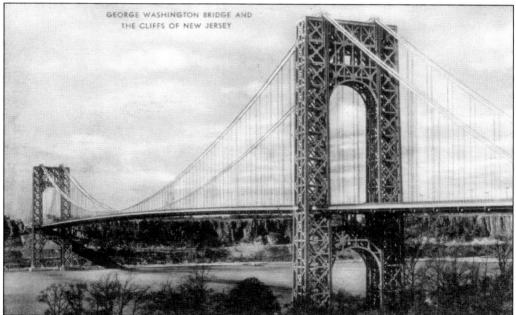

GEORGE WASHINGTON BRIDGE AND CLIFFS OF NEW JERSEY. Not only is the George Washington Bridge one of the distinctive features of the skyline of upper Manhattan, it was also the first bridge connecting New Jersey with Manhattan. It also offers excellent views of the midtown Manhattan skyline (not visible in this Mayrose Company postcard).

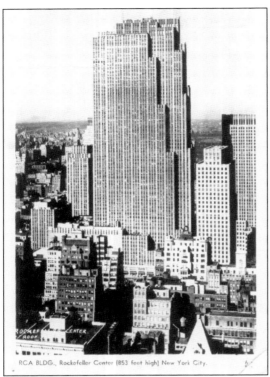

RCA BUILDING AND ROCKEFELLER CENTER COMPLEX. Rockefeller Center was conceived of by the wealthy John D. Rockefeller Jr. (1874–1960) as a "city within a city." Shown in this undated Foto Seal postcard, the RCA Building, now called 30 Rockefeller Plaza or the GE Building, is by far the tallest of the Rockefeller Center structures. Designed by a team of architects, including the noted art deco architect Raymond Hood, and completed in 1933, the towering RCA (which stands for Radio Corporation of America) Building is more than 70 stories high, rising 853 feet above the ground. Originally constructed to house radio studios, the building later became home to the National Broadcasting Company's television studios.

RCA BLDG., Rockefeller Center (853 feet high) New York City.

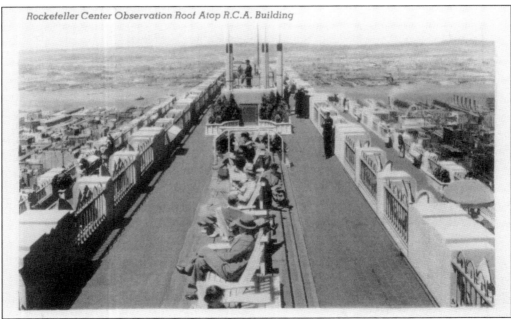

Rockefeller Center Observation Roof Atop R.C.A. Building

RCA BUILDING OBSERVATION DECK. Amazing views of Central Park can be had from the top of the GE Building. The observation deck first opened in 1933; one of its famous visitors was French general Charles de Gaulle. It was closed in 1986 and remained closed for nearly 20 years while undergoing a major renovation. The deck is now known as the Top of the Rock.

ROCKEFELLER CENTER FROM FIFTH AVENUE. This interesting Lumitone Photoprint postcard from the 1930s shows the Rockefeller Center complex in an Impressionistic rendering from Fifth Avenue. The RCA Building is at center, and two 45-story buildings flank it to the left and right. In the foreground are La Maison Francaise, the British Empire Building, and the proposed Italian and German Buildings.

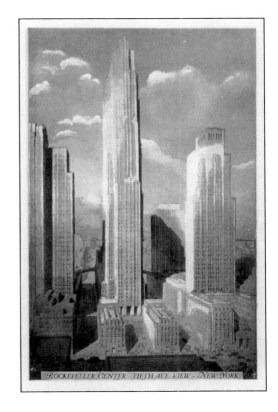

STATUE OF ATLAS. A 7-ton bronze statue of Atlas stands at Rockefeller Center. This 45-foot-high giant carries on his shoulder the largest armillary sphere ever to be cast. The sphere carries on its outer ring the 12 signs of the Zodiac and its axis points to the North Star. It was designed by Lee Lawrie and Rene Chambellan in 1936, and its style complements the art deco architecture of the Rockefeller Center buildings.

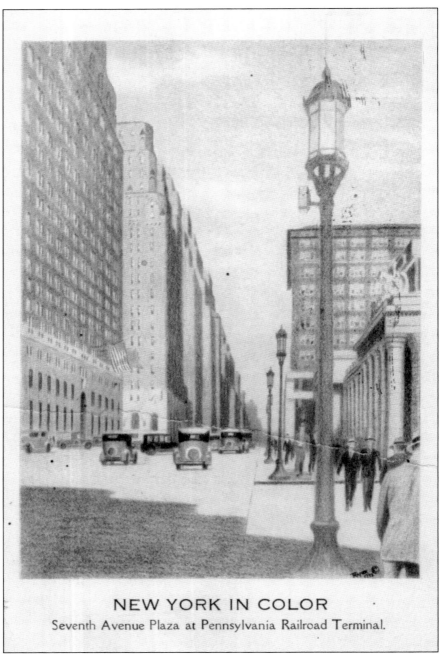

NEW YORK IN COLOR

Seventh Avenue Plaza at Pennsylvania Railroad Terminal.

SEVENTH AVENUE HOTELS. This postcard is a Lumitone Photoprint Trapier Colorpoeme, Series 32. The Colorpoeme series reproduced the works of an artist named Pierre Trapier. This shows a view looking south along Seventh Avenue from Pennsylvania Station. The caption on the reverse of the card reads, "Changing the drab dwellings of 'little old New York' into towering hotels and office buildings, the great Pennsylvania railroad has waved a magic wand over the whole West Side of Manhattan. Its titanic railway station faces a new Seventh Avenue that welcomes the city's guests to all the wonders and glories of New York."

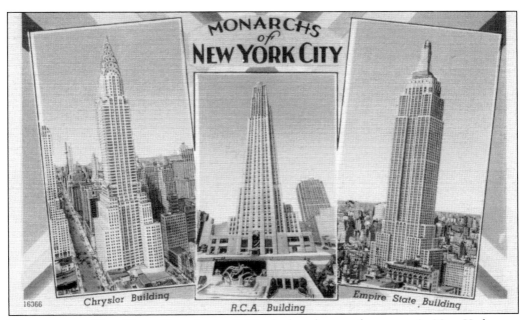

MONARCHS OF NEW YORK CITY. In the 1940s, the best-known skyscrapers in New York were three recent additions to the skyline—the Chrysler Building, the RCA Building, and the Empire State Building (in its pre-antenna days), all pictured here on this *c.* 1940 linen postcard. These three eclipsed in fame and height the old favorites—the Singer Building and the Woolworth Building.

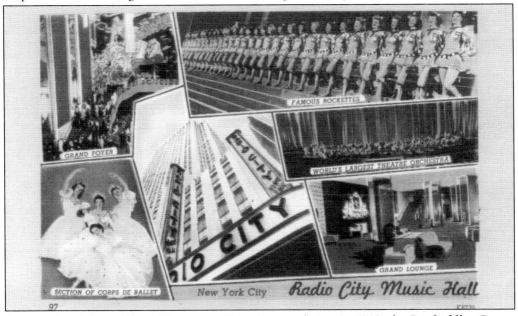

RADIO CITY MUSIC HALL MONTAGE. Since its completion in 1940, the Rockefeller Center complex of buildings has been a major attraction, notably Radio City Music Hall, which opened in 1932. This linen postcard montage shows (clockwise from bottom left) the Grand Foyer of Radio City Music Hall, ballet dancers, the Rockettes, the theater orchestra, the Grand Lounge, and an exterior shot showing the marquee.

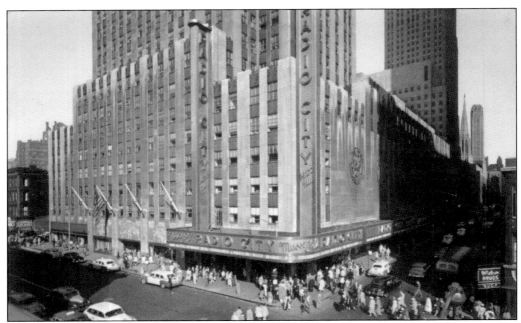

RADIO CITY EXTERIOR IN CONTEXT OF COMPLEX. This late-1950s chrome postcard shows the famous exterior signage of Radio City Music Hall. It is known for the annual Christmas Spectacular that runs for a sold-out eight weeks every Christmas season. Radio City has received more than 300 million visitors over the years.

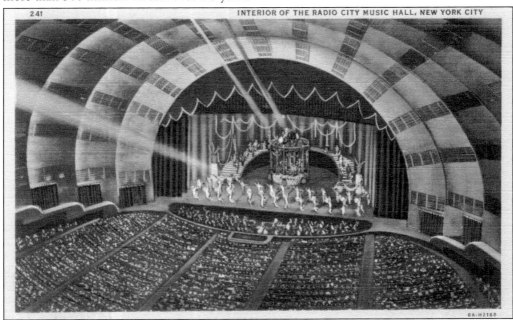

RADIO CITY MUSIC HALL THEATER. An integral part of the Rockefeller Center complex, Radio City Music Hall was touted as the largest movie theater in the world at the time of its completion (6,200 seats). Movies are no longer shown there; its focus is live shows and concerts. It is depicted here in an undated Curteich-Chicago Art-Colortone postcard from the early 1940s.

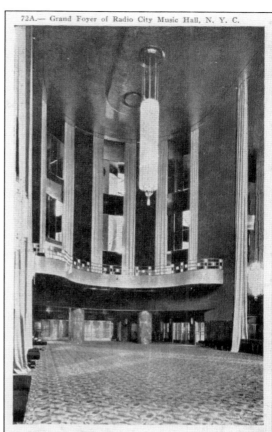

RADIO CITY MUSIC HALL, INTERIOR.
These two 1940s postcards show the
interior of Radio City Music Hall. At
right is a view of the ornate art deco
Grand Foyer, and below is a view looking
toward the stage from the back of the
theater. The theater's midtown location
is one of the keys to its longtime success;
it is easily accessible via subway and bus.

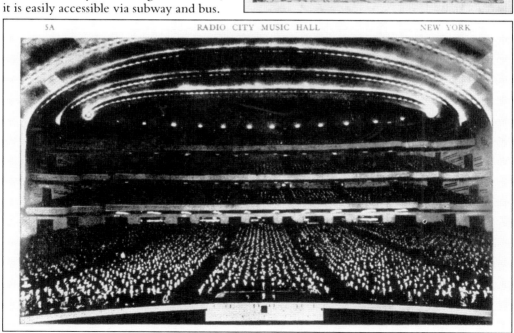

5A RADIO CITY MUSIC HALL NEW YORK

SUNKEN GARDENS AT ROCKEFELLER CENTER. The Rockefeller Center complex is notable in that it is one of the earliest uses in the city of plazas and gardens to offset skyscrapers. The Prometheus Fountain in the Sunken Plaza was designed by Paul Manship. Seen in this 1930s linen Manhattan Post Card Publishing Company image, the fountain is centered against the west wall of the Sunken Plaza between Forty-ninth and Fiftieth Streets. The sunken gardens and fountain provide a place for reflection and create a sense of open space, despite the towering buildings surrounding it.

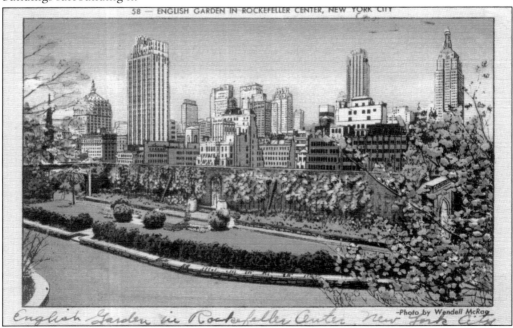

ENGLISH GARDEN AT ROCKEFELLER CENTER. One of 12 gardens in the Gardens of the Nations on the 11th floor of the towering RCA Building in Rockefeller Center, the English Garden features a 12-foot-long rectangular pool. Other Rockefeller Center buildings with rooftop gardens are the British Empire Building and Maison Francaise. This postcard dates to the early 1940s.

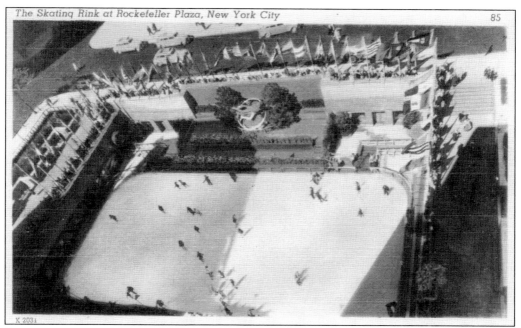

ROCKEFELLER SKATING RINK. The Rockefeller Center skating rink, located in the Sunken Plaza, is one of the most popular wintertime destinations in New York City. The 122-foot-long by 59-foot-wide skating rink first opened in 1936. Throughout the winter, visitors and residents alike skate on the sunken rink (capacity 150 persons), as seen in this undated Colourpicture linen postcard. Besides the skating rink, tourists also flock to see the monumental Rockefeller Center Christmas tree, a tradition that started in 1933 with a 50-foot tree.

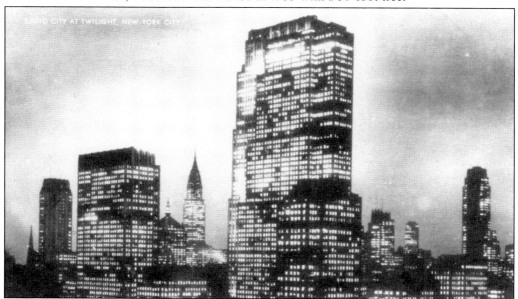

RADIO CITY AT TWILIGHT. Seventeen buildings comprise the huge Rockefeller Center complex, located on about 15 acres between Forty-eighth and Fifty-second Streets from Fifth to Sixth Avenues. The Chrysler Building is visible in the background on this undated Mayrose postcard.

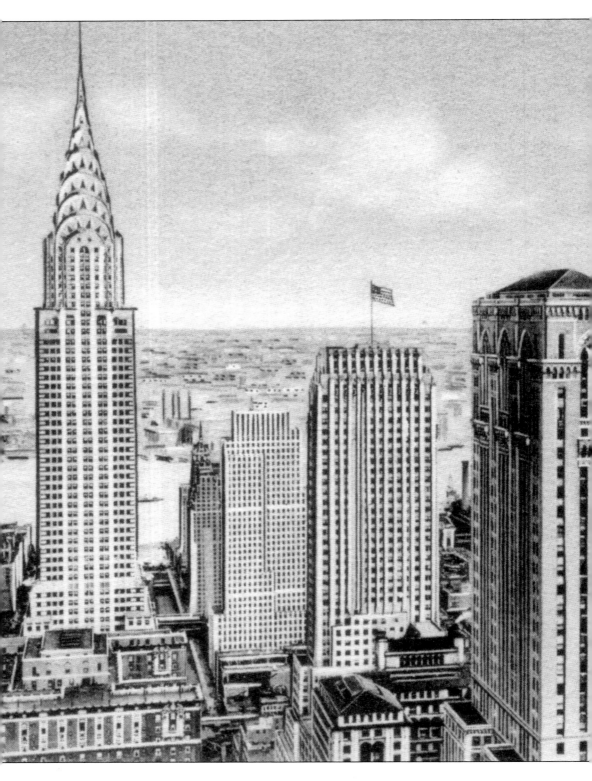

MIDTOWN SKYSCRAPERS.
This *c.* 1941 Curt
Teich Photo-Platin
postcard shows five
midtown skyscrapers.
From left to right are
the Chrysler Building,
Daily News Building,
Chanin Building (with
flag), Lincoln Building,
and Lefcourt Colonial
Building. The 36-story
Daily News Building
(the *Daily News* no
longer occupies the
structure) was designed
by Raymond Hood
and completed in 1929.
The Chanin Building,
designed by Sloan
and Robertson, was
completed in 1929
and is located at 122
East Forty-second
Street. The Lefcourt
Building, at 454 feet
high, was built in 1929
at Forty-first Street and
Madison Avenue, one
of several structures in
Manhattan bearing the
name of the Lefcourt
development company.

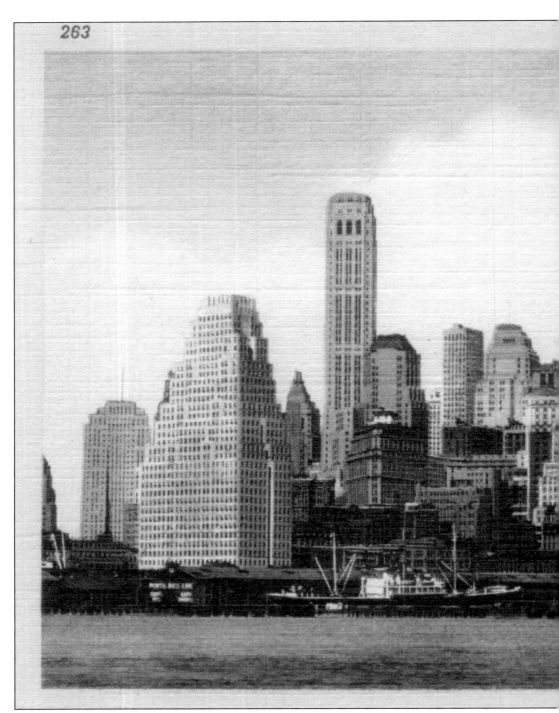

SKYLINE OF LOWER MANHATTAN. The three tallest buildings in this Curteich-Chicago postcard from the 1940s were all constructed during the Great Depression. From left to right are the 59-story, 741-foot-high 20 Exchange Place, also known as the City Bank-Farmers Trust Building (built 1931); the 66-story, 952-foot-high American International Building (built in 1932); and

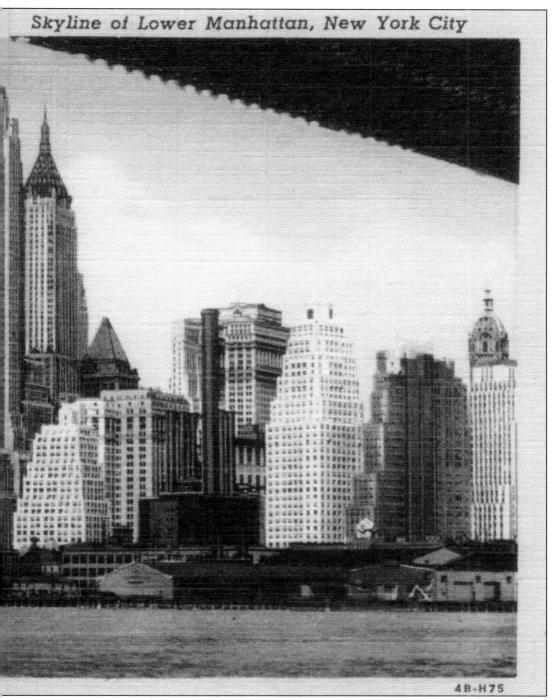

Skyline of Lower Manhattan, New York City

4B-H75

the 70-story, 927-foot-high 40 Wall Street, also known as the Bank of Manhattan Trust Building (designed by Craig Severance, Inc. and built in 1930). The massive waterfront building just left of 20 Exchange Place is 120 Wall Street, a 430-foot-high, 36-story art deco structure designed by Ely Jacques Kahn.

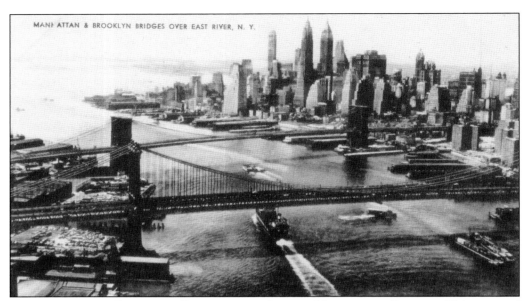

MANHATTAN AND BROOKLYN BRIDGES WITH LOWER MANHATTAN SKYLINE. This postcard shows the skyline of lower Manhattan as it appeared during the 1930s and 1940s, seen from the East River. The tallest structures, from left to right, are 20 Exchange Place, also known as the City Bank-Farmers Trust Building; the American International Building; and 40 Wall Street, also known as the Bank of Manhattan Trust Building (built in 1930).

LOWER MANHATTAN SKYLINE. This is the cover image from a *c.* 1940 Interborough News Company souvenir postcard booklet. The view looks southeast toward lower Manhattan. The three tallest buildings are, from left to right, the American International Building, 20 Exchange Place, and the Bank of Manhattan Trust Building.

THE 1939–1940 WORLD'S FAIR. This postcard shows the Belgian Pavilion at the 1939–1940 World's Fair in Flushing Meadow, Queens. The Belgian complex featured a 150-foot-tall tower made of gray slate. This was by no means the tallest structure in the fairgrounds; the 700-foot-high, needle-shaped Trylon dominated the World's Fair and northern Queens's skyline.

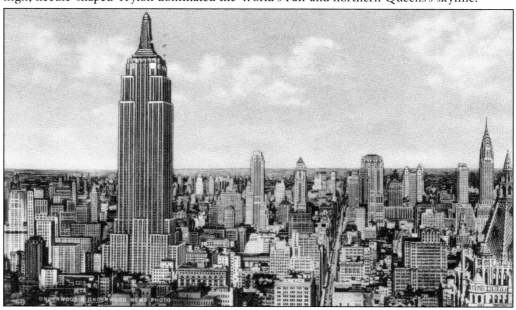

EMPIRE STATE WITH CHRYSLER BUILDING. A *c.* 1941 Curt Teich postcard highlights the Empire State Building (left foreground), which was for years the tallest building in the world. Also visible is the Chrysler Building (far right), the second tallest building in the world at the time. Because they were completed within a year of each other in distinctive art deco style and were long the one-two combination, these two New York landmarks will always be linked to each other.

124:—CATHEDRAL ST JOHN THE DIVINE. NEW YORK CITY.

CATHEDRAL OF ST. JOHN THE DIVINE. Work on this monumental cathedral located at Amsterdam Avenue between 111th and 113th Streets was begun on St. John's Day in 1892. Construction progressed slowly on what would become one of the largest places of worship in the world. Even today, impressive though it is, the church is still not completely finished as planned. Seen in this *c.* 1952 Manhattan Post Card Publishing Company image, the building is 445 feet high and is visible from 25 miles away. J. P. Morgan contributed $500,000 to the construction effort.

INTERIOR, CATHEDRAL OF ST. JOHN THE DIVINE. This *c.* 1939 interior image (created in England) shows the Baptistry at the Cathedral of St. John the Divine. In 1941, the cathedral was consecrated, and the full length of the interior of the church was opened to the public. The full extent of the original plans was never completely built. There was a fire in the north transept in 2001. The cathedral was rededicated, and the entire interior reopened to the public in 2008.

110

VIEW FROM WASHINGTON ARCH.
The construction of the Empire State
Building made a big impact on the
skyline of New York City. Because
of its height, it can be spotted from
numerous vantage points, though to
a lesser degree than when it was first
built and there were fewer skyscrapers
to obscure the view. In this Harry H.
Baumann postcard from the 1940s,
the skyscraper can be seen from the
vantage point of the Washington Arch
at the beginning of Fifth Avenue.

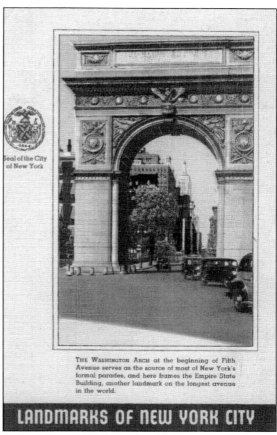

Seal of the City
of New York

THE WASHINGTON ARCH at the beginning of Fifth
Avenue serves as the source of most of New York's
formal parades, and here frames the Empire State
Building, another landmark on the longest avenue
in the world.

LANDMARKS OF NEW YORK CITY

**OVERLOOKING STATUE OF LIBERTY
IN UPPER NEW YORK BAY.** This
Mayrose Company image from the
1940s shows the Manhattan skyline
from lower Manhattan to midtown.
The Empire State Building is visible
at far left. The Singer and Woolworth
Buildings are the two tallest buildings
close to the tip of Manhattan.

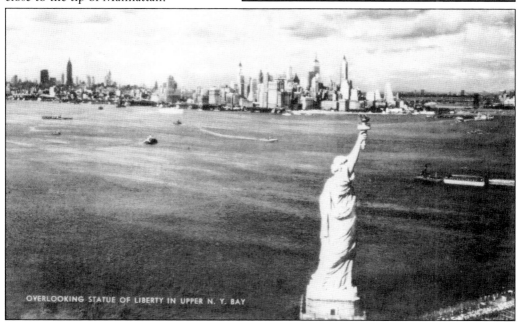

OVERLOOKING STATUE OF LIBERTY IN UPPER N. Y. BAY

GREETINGS FROM NEW YORK. Three icons of New York City are shown on this undated postcard from the 1940s. From left to right are the Empire State Building, the Statue of Liberty, and the RCA Building at Rockefeller Center. The "star attractions" of New York postcards changed over the years as new skyscrapers were constructed.

THE PENN ZONE. This aerial view, probably from the 1940s, shows the Penn Zone, or the area between Thirty-first Street and Thirty-fourth Street from Fifth to Eighth Avenues (near Pennsylvania Station). Numbered in this view are several skyscrapers and landmarks, including 1.) Empire State Building, 2.) Pennsylvania Station, 3.) Hotel Martinique, 4.) Hotel McAlpin; 5.) Hotel Pennsylvania, 6.) Hotel New Yorker, 7.) Hotel Governor Clinton, 8.) Macy's, 9.) Saks 5th Avenue, 10.) Gimbel's Department Store, and 11.) General Post Office.

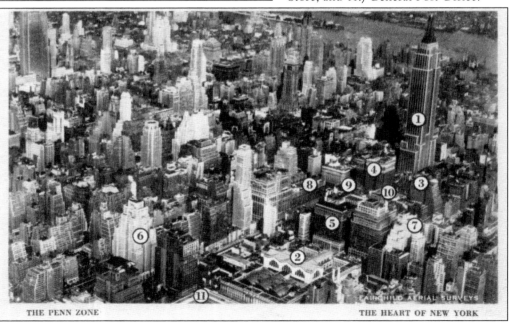

THE PENN ZONE THE HEART OF NEW YORK

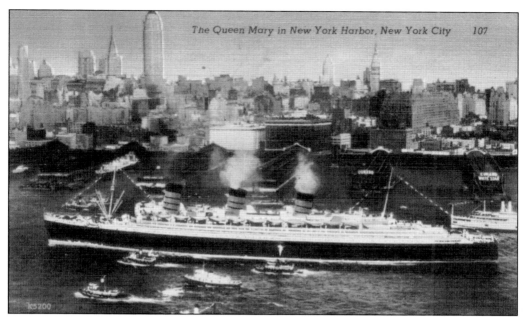

QUEEN MARY AND NEW YORK SKYLINE. This 1940s linen Colourpicture postcard, published by the Herbco Card Company, shows the *Queen Mary* in New York Harbor. The Empire State Building is visible toward the left, the tallest structure in the image. The *Queen Mary* was in service between 1936 and 1967.

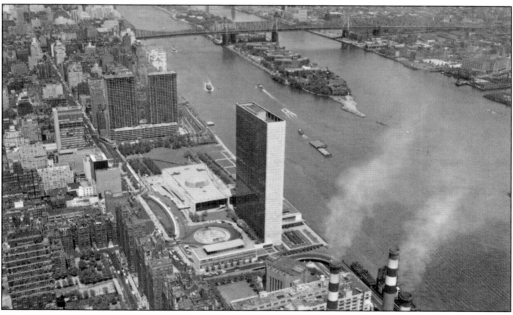

UNITED NATIONS COMPLEX, AERIAL VIEW. The United Nations was first housed in temporary headquarters on Long Island and moved to its newly completed home in Manhattan in 1952. This Mainzer image dates from the 1960s or 1970s and shows an aerial view of the United Nations complex (Forty-second Street to Forty-eighth Street from First Avenue to the East River). The East River and the Fifty-ninth Street Bridge are also visible.

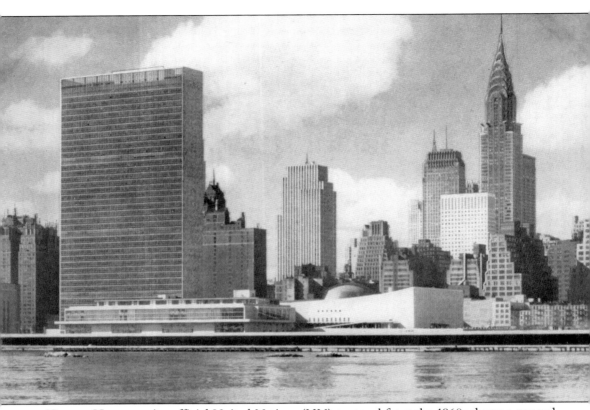

UNITED NATIONS. An official United Nations (UN) postcard from the 1960s shows a general view of the UN complex from the East River, consisting of the General Assembly Hall (completed 1952); conference area; 39-story, 510-foot-high Secretariat Building; and the Dag Hammarskjold Library (completed 1963). Since its completion in 1950, the Secretariat Building (designed by Le Corbusier and Oscar Niemayer) has been the dominant feature of midtown Manhattan's East River waterfront. In this postcard, the Chrysler Building is visible at right. The selection of New York as the location for the United Nations headquarters gave the city extra political clout and made it a hot spot for international diplomats.

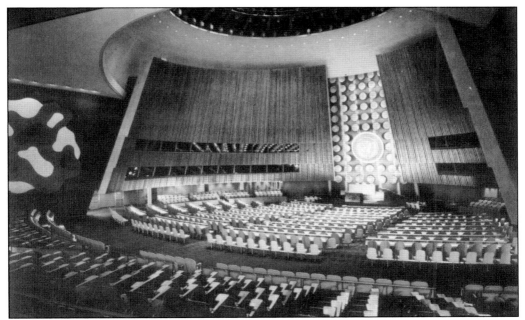

GENERAL ASSEMBLY HALL AT UNITED NATIONS. This official United Nations photo postcard shows the General Assembly Hall, which can seat 1,800 people. The member states gather in the General Assembly Hall to discuss problems and issues faced by the world.

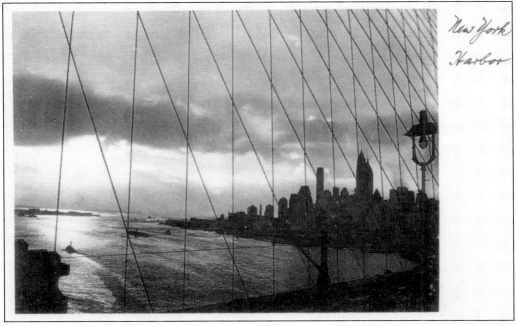

New York Harbor

BRIDGE VIEW. This artistic view of the New York skyline and harbor was taken from the Brooklyn Bridge in the 1940s or 1950s on an Arthur Jaffe postcard printed in Vienna, Austria.

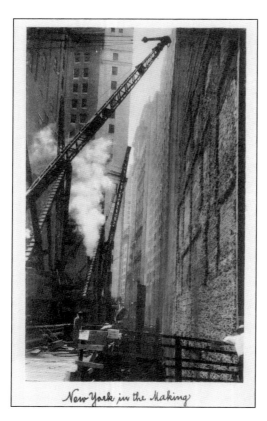

New York in the Making

NEW YORK IN THE MAKING. This Austrian-made Arthur Jaffe photo postcard shows cranes at a construction site in downtown New York City, probably in the 1940s or 1950s. For more than 100 years, major construction projects in the city have been ongoing. Old buildings are constantly being razed to make way for new skyscrapers.

LITTLE CHURCH AROUND THE CORNER. This undated Natural Color Mainzer postcard shows the Episcopal Little Church around the Corner (also known as Church of the Transfiguration), located at One East Twenty-ninth Street (between Fifth and Madison Avenues). In the background is the Empire State Building, a few blocks to the north. Since the skyscraper has no antenna, that dates the image to before 1952.

Five

1955–Present

Between the mid-1950s and present day, the skyline of New York City has changed dramatically. Hundreds of glossy new skyscrapers have been constructed over the last 50 years; in fact, of the 20 tallest buildings in New York City, 14 were constructed after 1950 and 12 of them after 1970. This chapter gives just a sampling of some of the city's more recently constructed skyscrapers, including the Pan Am Building, the World Trade Center, and the Marriott Marquis Hotel. The Freedom Tower, being constructed on the site of the Twin Towers, is just one of a new breed of skyscrapers that will overtake the Empire State Building in height in the coming years. New York's impressive skyline promises to continue to evolve and grow.

666 FIFTH AVENUE. Depicted here is the Top of the Six's Restaurant, located at the top of 666 Fifth Avenue (also known as the Tishman Building). The 483-foot-high, 41-story office building, located between Fifty-second and Fifty-third Streets, was designed by Carson and Lundin. Built in 1957, it is located near Rockefeller Center. The restaurant, famous for its views of midtown Manhattan, closed in the 1990s. Rooftop skyscraper restaurants used to be more popular in Manhattan, but many have closed in recent years.

HOTEL AMERICANA. Designed by Morris Lapidus and Associates, the Hotel Americana (2,000 rooms) was built in 1962 at Seventh Avenue and Fifty-second Street. The 550-foot-high, 50-story building was the tallest concrete building in the world when constructed. It was also the first new hotel to be constructed in Manhattan in about 30 years. The Americana later became the Sheraton Centre.

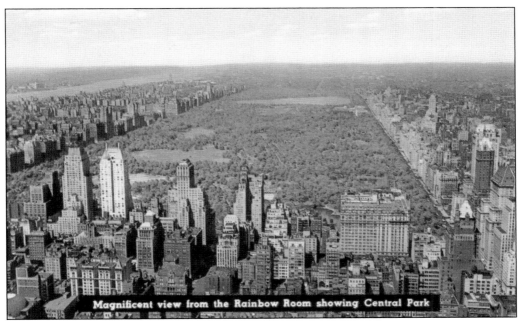

Magnificent view from the Rainbow Room showing Central Park

CENTRAL PARK SOUTH. This Plastichrome image from the 1960s shows a view looking north from the Rainbow Room restaurant at Rockefeller Center. Residential skyscrapers line Central Park South and also Central Park East and West; farther north, building heights decrease.

PAN AM BUILDING. The Pan Am Building at 200 Park Avenue (near Grand Central Terminal) is one of the modern icons of New York City. At the time of its completion in 1963, it was the largest commercial building in the world. With 59 floors, the building has 2.4 million square feet of office space and can accommodate 17,000 office workers. The building was sold to MetLife in 1981. It is shown in an undated Nester's Map and Guide image.

VERRAZANO NARROWS BRIDGE.
This Mirro-Krome Card published
by Nester's Map and Guide
Corporation shows the Verrazano
Narrows Bridge, a 6,690-foot-
long suspension bridge connecting
Brooklyn and Staten Island. Opened
in November 1964, it was named
after the first European explorer to
enter New York Harbor, in 1524.

CITY SQUIRE MOTOR INN. The
City Squire (a Loews hotel) opened
in the 1960s at Broadway between
Fifty-first and Fifty-second Streets in
Manhattan. Featuring 21 floors and
727 rooms with a swimming pool and
Finnish sauna, it was deemed a motor
inn (a rarely used term in Manhattan)
because it featured an in-hotel garage.

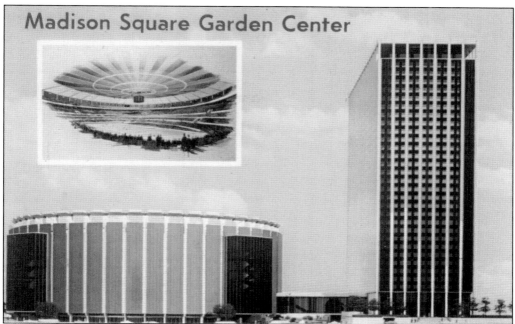

Two Penn Plaza. The new Madison Square Garden sits on the spot where the old Pennsylvania Station was before it was demolished in 1963. The 29-story Two Penn Plaza, completed in 1968 and shown in a rendering on this postcard, was later joined by the 57-story One Penn Plaza (completed 1972). This image is deceptive because, in real life, Two Penn Plaza is in front of Madison Square Garden.

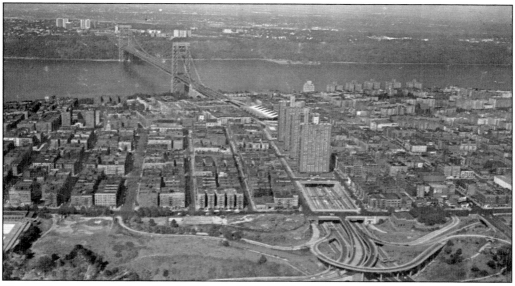

Upper Manhattan. The tallest buildings visible in this 1970s view of the northernmost reaches of Manhattan are four high-rise apartment buildings located near the George Washington Bridge Bus Station. Skyscrapers are most likely to be built in areas that are easy to reach and are the most commercially prosperous, another reason for the clustering of tall buildings in midtown Manhattan.

GREETINGS FROM NEW YORK CITY. This *c.* 1975 Plastichrome postcard proclaims New York to be the "Entertainment Capital of the World" and shows the RCA Building, Statue of Liberty, Empire State Building, and United Nations Building. The Statue of Liberty has always been a popular postcard subject, especially during the American bicentennial.

TWIN TOWERS. The Twin Towers (part of the World Trade Center complex) dominated the lower Manhattan skyline from their completion in 1973 to their destruction in September 2001. This *c.* 1975 Hudson River view shows the Twin Towers before the adjacent Battery Park City complex or World Financial Center were constructed. Without any structures in front of them, they were visible in their entirety from the Hudson River.

I LOVE NEW YORK. The slogan "I Love New York" was created by an advertising agency in the 1970s, and though only intended to be short-term, it still resounds today. In this 1980s postcard view looking south from around Forty-second Street, the Empire State Building and World Trade Center are visible.

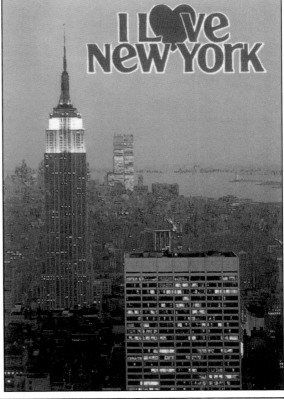

TWIN TOWERS AND LOWER MANHATTAN. In this postcard from the early 1980s, the Twin Towers easily dominate the lower Manhattan skyline. The Battery Park City development (only three buildings in this view) is just taking shape at left of the Twin Towers, on landfill.

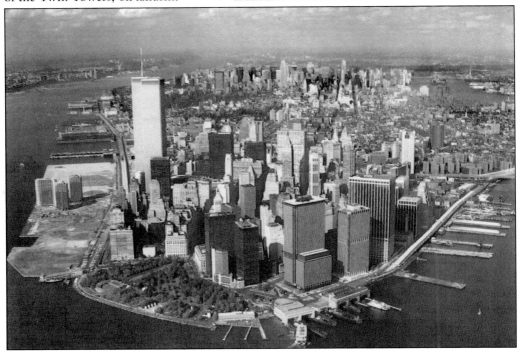

TRUMP TOWER. Donald Trump was the developer for this 58-story, 664-foot-high glass and concrete tower located at 725 Fifth Avenue. The building, designed by Der Scutt, was completed in 1983. This photograph was taken by the author around 1991.

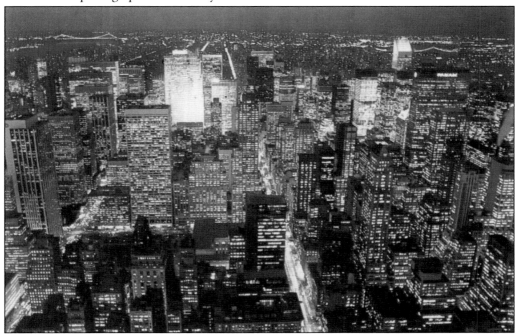

MIDTOWN MANHATTAN AT NIGHT. The Manhattan skyline at night is a wondrous sight with all the bright lights creating a warm glow. The Pan Am and Citicorp buildings are visible in the upper right of the postcard, which dates to the 1980s. The distinctive Citicorp Building, with its angled roof, was designed by Hugh Stubbins and Associates and completed in 1978.

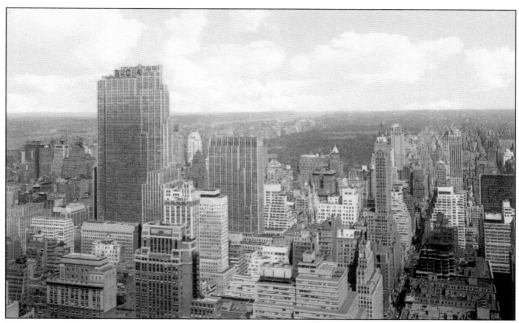

MIDTOWN SKYLINE LOOKING NORTH. The Rockefeller Center complex of buildings is located in the left center of this undated postcard. The Hudson River is visible on the horizon at left, and Central Park is also visible toward the top center. The RCA Building's dominance of the midtown skyline is pronounced in this Acacia Card Company image.

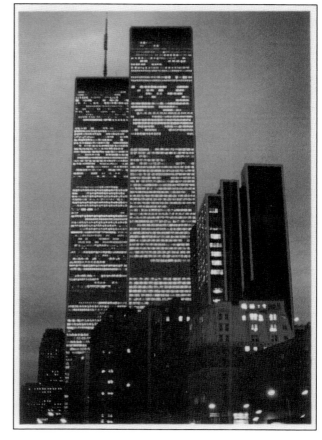

TWIN TOWERS AT NIGHT. The closer one got to the World Trade Center complex, the more towering the two giant buildings seemed. This postcard dates to the 1980s.

MARRIOTT MARQUIS HOTEL. Designed by John Portman, this 574-foot-high building opened in 1985 at 1535 Broadway (Forty-fifth Street) and was one of the first steps in the revitalization of Times Square. It features a 47-story atrium and a lobby located on the eighth floor. It is well known for its lighted glass elevators, which zip patrons up and down along a central elevator core. There is also a theater in the hotel, which was home to the hit show *Me and My Girl*. Another popular feature of the hotel is its revolving rooftop restaurant, The View. This oversized postcard dates to around 1987.

BIBLIOGRAPHY

Chase, W. Parker. *New York 1932: The Wonder City*. New York: New York Bound, 1983.

Dolkart, Andrew S. *Guide to New York City Landmarks*. Washington: The Preservation Press, 1994.

Let's Cover the Waterfront. New York: Circle Line–Sightseeing Yachts, Inc., 1964.

Lyman, Susan Elizabeth. *The Story of New York*. New York: Crown Publishers, 1975.

Willensky, Elliot, and Norvalk White. *AIA Guide to New York City*. New York: Harcourt Brace Jovanovich, 1988.

Wolfe, Gerard R. *New York: A Guide to the Metropolis, Walking Tours of Architecture and History*. New York: New York University Press, 1983.

Wurman, Richard Saul. *NYC Access*. New York: Access Press, 1989.

DISCOVER THOUSANDS OF LOCAL HISTORY BOOKS FEATURING MILLIONS OF VINTAGE IMAGES

Arcadia Publishing, the leading local history publisher in the United States, is committed to making history accessible and meaningful through publishing books that celebrate and preserve the heritage of America's people and places.

Find more books like this at
www.arcadiapublishing.com

Search for your hometown history, your old stomping grounds, and even your favorite sports team.